PRE-RAPHAELITE
Paintings and Graphics

PRE-RAPHAELITE
Paintings and Graphics

MARTIN HARRISON

revised by
SUSAN MILLER

ACADEMY EDITIONS · LONDON
ST MARTINS PRESS · NEW YORK

First published in Great Britain in 1971
by Academy Editions 7 Holland Street London W8.

Revised and enlarged edition 1973.

SBN cloth 902620 16 9 SBN paper 902620 17 7

First published in the U.S.A. in 1973 by St. Martin's Press Inc.,
175 Fifth Avenue, New York N.Y. 10010.
Affiliated publishers: Macmillan Company Limited, London -
also at Bombay, Calcutta, Madras and Melbourne.

Printed and bound in Great Britain at The Pitman Press, Bath.

INTRODUCTION

The 'Pre-Raphaelite rebellion' in 1848 was not an isolated artistic phenomenon but related to the social and artistic dissatisfaction widespread in Britain and Europe in the 1840's. The first Chartist riots occurred in 1848, the Oxford Movement, Maurice's Christian Socialism, the teachings of Kingsley and Carlyle were symptomatic of a rapidly changing society. The early nineteenth century had seen the rise of taxonomy, the acceleration of science and the invention of photography; the Gothic Revival in architecture, under the initial leadership of Pugin, had got under way in the 1830's. All of these factors were to influence the Pre-Raphaelites.

Since the days of the dominance of the man the Pre-Raphaelites termed Sir 'Sloshua' Reynolds there had been a steep decline in English painting. Artists slavishly adhered to the principles laid down by Reynolds—the Academy and 'grand art' reigned supreme. In Europe the rebellion had already started. A group of Germans, the Nazarenes, including Overbeck, Cornelius and Führich had moved to Rome. In France a group called *Les Primitifs* formed under Ingres, their cool and rational style in opposition to the Romanticism of Delacroix. A group called the *Clique* had already dissented from the Royal Academy Schools in 1837. They were, however, not as original as the Pre-Raphaelities and less articulate and soon fragmented. An important English forerunner of the Pre-Raphaelites was William Dyce who had studied the Nazarenes and Italian frescoes. When choosing the decoration for the newly built Houses of Parliament (by Pugin and Sir Charles Barry), Prince Albert had favoured the Nazarenes but was advised to choose an Englishman and Dyce was found to be an admirable substitute.

However, although they were not completely isolated the impact of the Pre-Raphaelite Brethren in 1848 must have been very violent. Firstly their use of colour; the brilliant early canvases of Hunt and Millais used the whole spectrum, diametrically opposed to the dull green and browns of the Academician's palettes. Theirs was basically a doctrine of *plein-airism*—the Academicians rarely left the studio. Stifling rules about 'central-focus' composition were thrown over and many of the pictures had a new 'social realism'. The Pre-Raphaelites were still narrative artists but changed from the subject matter of men like E.M. Ward and Augustus Egg to illustrate their favourite authors, Malory, Tennyson and Keats.

In May 1848 Dante Gabriel Rossetti began to paint under the tutelage of Ford Madox Brown. Recognising Rossetti's technical limitations Brown set him to copying and then painting still-life but Rossetti, his romantic hunger far from satisfied, left Brown to work on his own. Madox Brown's early influence on the group cannot be over-estimated however and it is important to realise that at this date he was already painting in basically a 'Pre-Raphaelite' style. Certainly Rossetti's technique improved considerably during his period under Madox Brown. Though intended by his father for a business career William Holman Hunt always wanted to paint. At first he attended evening art classes after his work for an estate agent, but fairly soon left to study full time for entry to the Academy Schools. At the third attempt he was admitted, first to draw from the antique and then into the Life School. At the Academy, Hunt established a strong friendship with the school's young genius—John Everett Millais. There, also, he first read John Ruskin's *Modern Painters* which preached the doctrine of 'fidelity to nature'.

Holman Hunt painted *The Eve of St. Agnes* for the 1848 Royal Academy exhibition. This was one of the first pictures which could truly be called Pre-Raphaelite. The inspiration was a Keat's poem, his models were taken from nature and the colours included 'Pre-Raphaelite' blues, violets and greens. The painting was finished off at Millais' studio while Millais was working at his *Cymon and Iphigenia*—a far more conventional albeit very accomplished work. The outcome was that *St. Agnes* was accepted by the R.A. and *Cymon* rejected. This very

probably persuaded Millais to take more notice of Hunt's new techniques and adopt them himself. The friendship between Hunt and Rossetti—who had met before—was cemented when Rossetti went to Hunt full of acclaim for *St. Agnes* and said it was the best picture in the Exhibition. By late 1848 Rossetti, Hunt and Millais had discussed the possibility of founding a new school of painting and this soon became a reality. Led by Millais and Hunt and spurred on by Rossetti's infectious enthusiasm, the group soon acquired four more members: Frederick George Stephens, James Collinson, Thomas Woolner the sculptor and Dante's brother, William Michael Rossetti. They called themselves the Pre-Raphaelite Brotherhood and adopted the insignia P.R.B. which appeared on their early pictures.

For the spring 1849 Royal Academy exhibition Hunt painted *Rienzi swearing revenge over his brother's corpse* and Millais *Lorenzo at the house of Isabella.* Rossetti sent his *Girlhood of Mary Virgin* to the free exhibition—all of these in the 'hard-edged' Pre-Raphaelite manner. It was not until the following year that the public and the critics realised what the letters P.R.B. by the artists' signatures stood for, but when it was discovered, the Brotherhood were considered by most as impudent young revolutionaries becoming the butt of much adverse criticism. Eventually, in 1851, Ruskin spoke out in their defence. He became a friend and patron of some of the Brethren and their followers, especially Rossetti and, later, Burne-Jones.

The severe discipline involved in producing 'true' Pre-Raphaelite pictures was, however, alien to Rossetti's nature and by the early 1850's he was painting brilliant, spontaneous watercolours, usually based on medieval legend such as *Iseult on the Ship* and *Sir Galahad at the Shrine*. These are neither realistic nor painted in the finely detailed, 'hard-edged' style of *The Two Gentlemen of Verona* or *Ophelia* and represent a quite separate development from the original aims of Pre-Raphaelitism. These watercolours illustrate what may be termed the 'second phase' of Pre-Raphaelitism.

By 1853 the P.R.B. had started to break up. Millais had gone to Scotland. He was elected an A.R.A. on his return late that year and was eventually to decline into a very commercial painter of portraits and sentimental subjects. In 1854 Holman Hunt went to Palestine to get a truer background for one of his increasingly didactic, moral, religious pictures. Throughout his long life he alone kept closely to the Brotherhood's original philosophies and techniques. Of the other members, Stephens had become an art critic, Woolner left for Australia and Collinson became converted to Catholicism in 1852 and joined a religious community. Walter Howell Deverell was proposed by Rossetti as a replacement for Collinson, but never actually elected.

It was in 1855 that the *Maids of Elfenmere* illustration by Rossetti was first seen, and made a tremendous impact on, the youthful Edward Burne-Jones. Burne-Jones and his lifelong friend, William Morris had already begun to consider becoming artists when they met Rossetti in 1856. He it was who persuaded Burne-Jones to throw up everything and become an artist. With Morris and Burne-Jones we move away from 'Pre-Raphaelitism' although the name has stuck to this very different, very important later development of the movement.

Morris and Burne-Jones took rooms together in Red Lion Square in 1856, Morris also having been persuaded by Rossetti to become a painter. In 1857-8 Rossetti conceived the idea of painting frescoes on the upper walls of the new Oxford Union building and enlisted Burne-Jones, Morris, Arthur Hughes, Stanhope, Val Prinsep and J.H. Pollen to each paint a section. This brought in an important associate of the group, Arthur Hughes and a 'second-phase Pre-Raphaelite', Roddam Spencer-Stanhope. Morris married in 1860, and moved into the 'Red House' built by Philip Webb. The experience of Morris and his friends in decorating this house, and furnishing their rooms previously, gave them the impetus to form, in 1861, Morris, Marshall, Faulkner & Company. Other partners in the firm were Burne-Jones, Rossetti, Madox Brown and Philip Webb.

'The Firm' as it was known was responsible for manufacturing very high quality furniture,

stained glass, tiles, tapestry, wallpaper, embroidered hangings, metalwork and for designing and painting interiors. In 1874 the firm was reformed on a more business-like basis as 'Morris & Co.' and Rossetti and Madox Brown dropped out. Burne-Jones by this time was solely responsible for designing the cartoons for the firm's large output of stained glass, the design and colour of which was in the 'aesthetic' rather than the 'gothic' style of the early 1860's. And when Morris founded the Kelmscott Press in 1893, his aim being to re-introduce the 'book beautiful', Burne-Jones produced the eighty-seven woodcut illustrations, printed within borders designed by Morris, for the Kelmscott 'Chaucer', the Press's most famous book. His decorative work ran parallel with his painting and by the seventies he was an accomplished mature artist painting superb, highly detailed canvases such as *The Hesperides, Laus Veneris* and *Chant d'amour.* By the time of his death in 1898 he had developed the original Pre-Raphaelite style to its fulfilment.

1971 Martin Harrison

PREFACE TO THE SECOND EDITION

This edition, now greatly enlarged, has been arranged chronologically to trace the evolution of Pre-Raphaelite art. From the inception of the Brotherhood there were two branches of the movement, with Hunt and Millais advocating a detailed naturalism while Rossetti explored the world of romantic nostalgia, showing little concern for strict realism in his evocative illustrations of medieval legends. The naturalists were, like Rossetti, concerned with narrative and with literary themes but emphasized the moral more often than the romantic and their career, though of revolutionary importance, was comparatively short-lived. It was the style of Rossetti which was to remain, gaining new life through the work of later artists like Burne-Jones and becoming finally fixed as the dominant and the most familiar aspect of Pre-Raphaelite art.

1973 Susan Miller

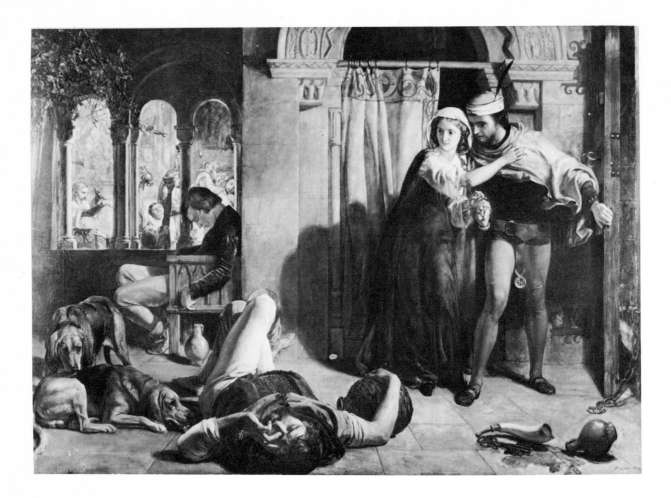

William Holman Hunt (1827-1910)
The Eve of St. Agnes. Oil on canvas, 30½" x 44½", c. 1848. Guildhall Art Gallery, London. Hunt, who often used literary themes to dramatize moral situations, interpreted Keat's poem as "the sacredness of honest responsible love and the weakness of proud intemperance." In 1848 Keats was almost unknown, his works having been published by Moxon only two years before. Rossetti, another Keats enthusiast, saw the painting at the 1848 Royal Academy exhibition and sought out Hunt as a friend and teacher. When the painting was sold for £70 Hunt rented a studio in Cleveland Street, which was shared by Rossetti.

John Everett Millais (1829-96)
Pen and ink designs for the decoration of Little Woodhouse, Leeds. c. 1848. William Morris Gallery, Walthamstow.
These lunette designs, studies for large oil paintings, clearly show the influence of the neo-classicists Retzch and Flaxman on the youthful Millais.

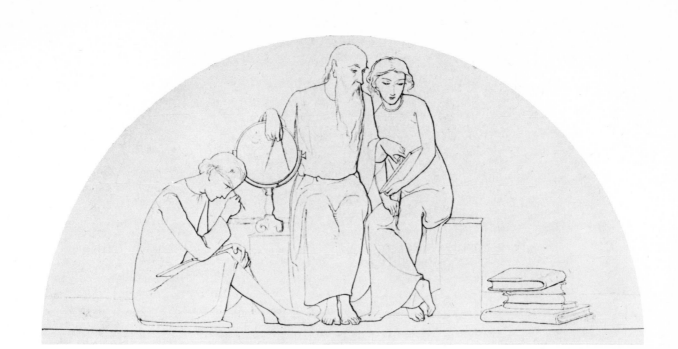

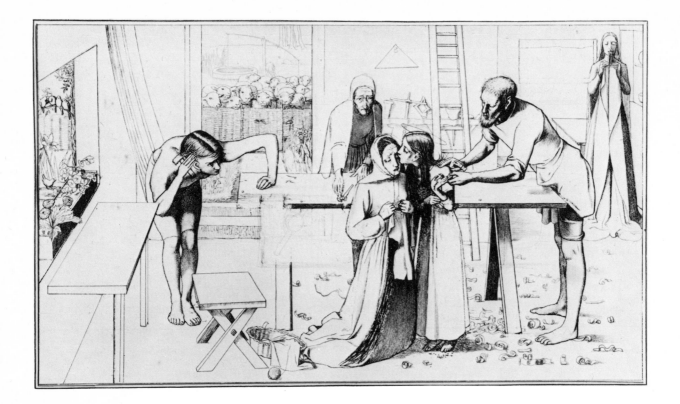

John Everett Millais (1829-96)
Study for *Christ in the House of His Parents*. Pen and ink, 7½" x 13", 1849. The Tate Gallery, London.
The oil painting, now at the Tate Gallery, for which this is a study was exhibited at the Royal Academy in 1850. Dickens wrote of it in *Household Words:* "In the foreground of that carpenter's shop is a hideous, wry-necked, blubbering, red-headed boy, in a bed gown, who appears to have received a probe in the hand, from the stick of another boy with whom he has been playing in an adjacent gutter, and to be holding it up for the contemplation of a kneeling woman, so hideous in her ugliness that, (supposing it were possible for any human creature to exist for a moment with that dislocated throat) she would stand out from the rest of the company as a Monster. . . "
This stands as one of the most vicious and ill-founded notices the Pre-Raphaelites ever received.

Dante Gabriel Rossetti (1828-82)
The Girlhood of Mary Virgin. Oil on canvas, 32¾" x 25¾", 1849. The Tate Gallery, London.
Rossetti was twenty when he completed his first painting. Shown at the Free Exhibition in 1849 it was the first picture exhibited in public to bear the initials "P.R.B."

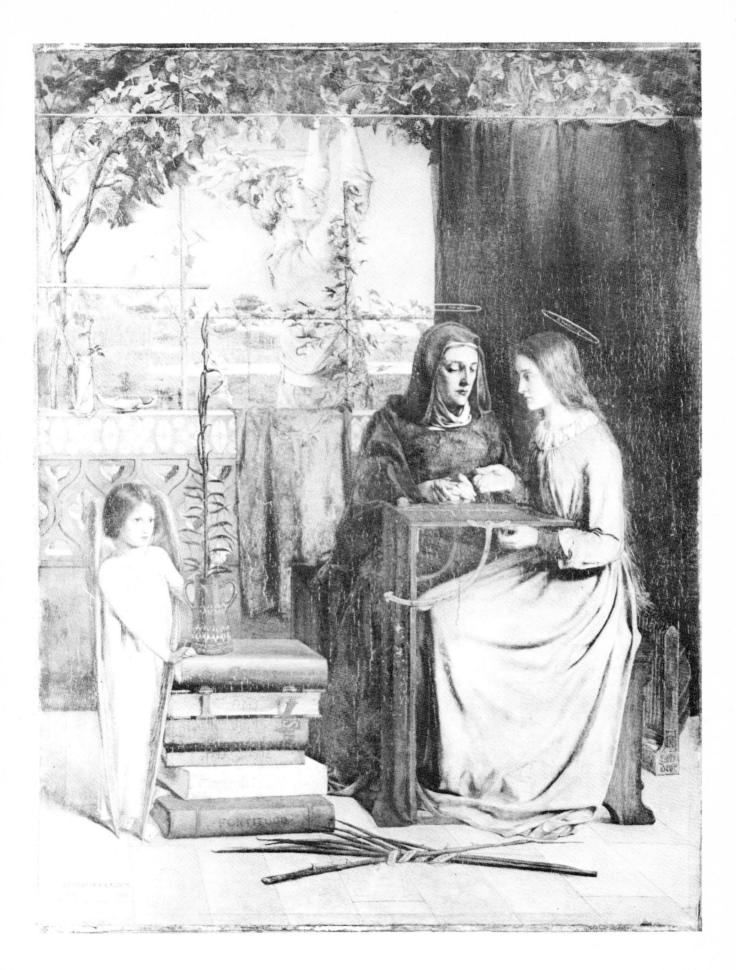

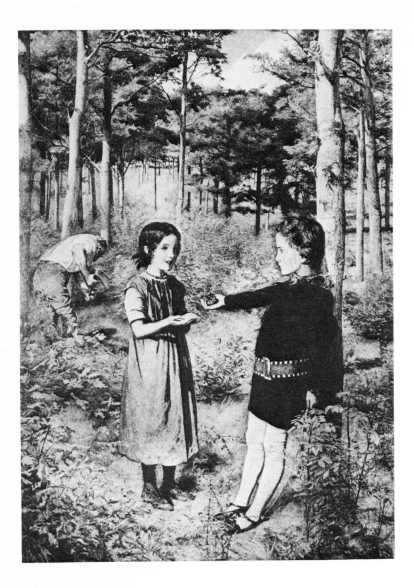

John Everett Millais (1829-96)
The Woodman's Daughter. Oil on canvas, 35" x 25½", 1851. The Guildhall Art Gallery, London.
Begun in 1849, *The Woodman's Daughter* was based on Coventry Patmore's poem and was exhibited at the Royal Academy with two verses quoted from the poem. As often happened with the Brotherhood, Millais repainted certain details much later, in 1886.

John Everett Millais (1829-96)
The Return of the Dove to the Ark. Oil on canvas, 34½" x 21½", 1851. Ashmolean Museum, Oxford.
The young Burne-Jones and Morris were inspired by this picture, which they saw displayed in the window of an Oxford art-dealer. Not so obviously original a religious painting as the controversial *Christ in the House of His Parents,* which it followed, it was one of Millais' contributions to the 1851 Royal Academy exhibition.

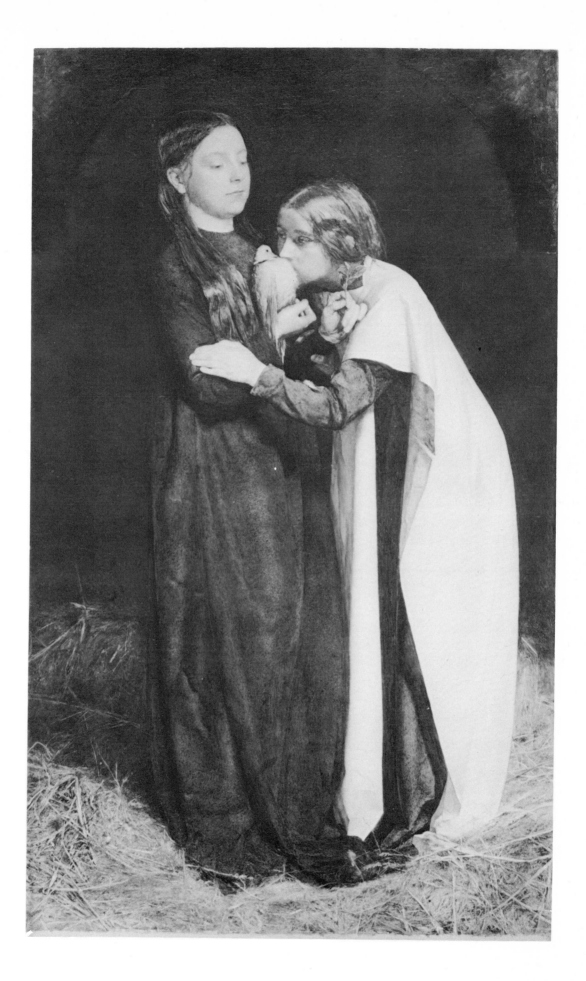

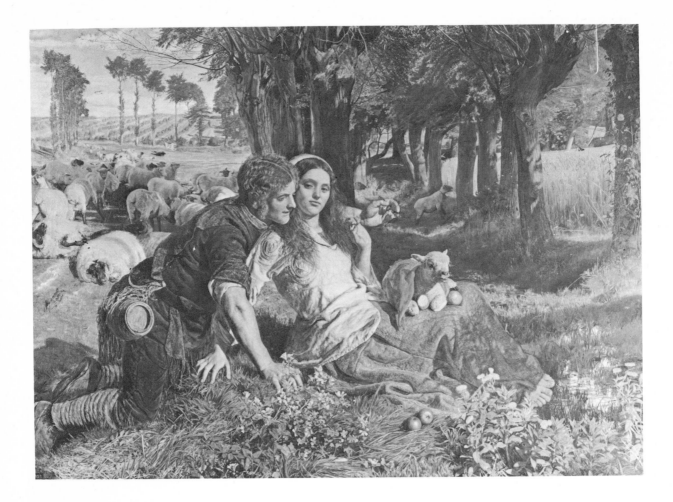

William Holman Hunt (1827-1910)
The Hireling Shepherd. Oil on canvas, 30" x 42½", 1851. Manchester City Art Gallery.
Painted at Ewell, near Surbiton, this early example of outdoor naturalism was meant as "a rebuke to the sectarian vanities and vital negligences of the day." The symbolism Hunt intended in his first moral painting was rather heavy-handed—the shepherd or "pastor" is neglecting the flock "which is in constant peril" to indulge in his own "vain" and irrelevant activities. The pastoral scene depicted here is opposed to the romantic vision of a completely harmonious relationship between the land and rural man.

John Everett Millais (1829-96)
Mariana. Oil on panel, 23½" x 19½", 1851. Private Collection.
Illustrating Tennyson's poem of that name, *Mariana* was badly received by the critics at its first exhibition.

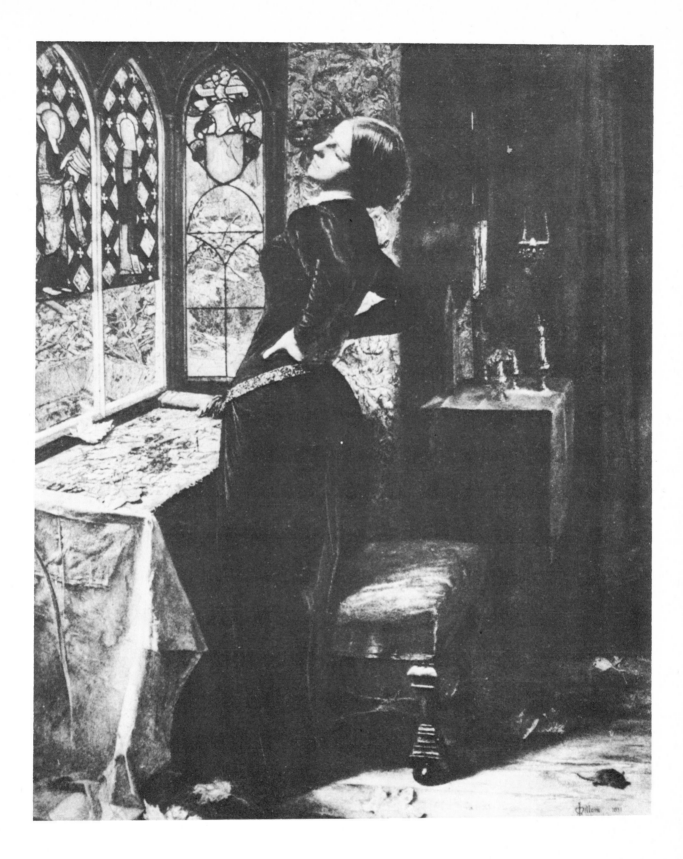

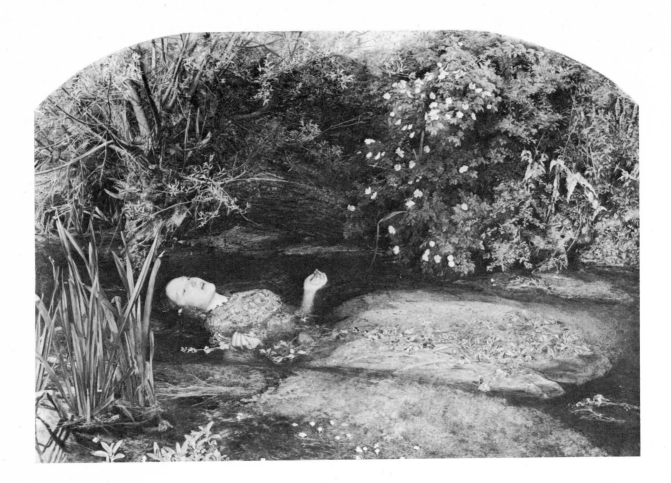

John Everett Millais (1829-96)
Ophelia. Oil on canvas, 30" x 40", 1852. The Tate Gallery, London.
Early in 1852 Elizabeth Siddal posed fully clothed in a bath of water for *Ophelia.* The background, begun in the summer of 1851 on the River Ewell, may be regarded as a yardstick of excellence in Pre-Raphaelite painting, with its brilliant colours and attention to detail. Millais' highly original conception of this scene from *Hamlet* was controversial with the press.

Walter Howell Deverell (1827-54)
The Pet. Oil on canvas, 33" x 22½", 1852-3. The Tate Gallery, London.
Deverell is now chiefly remembered as the man who discovered Elizabeth Siddal. He was, in fact, a close associate of the P.R.B.

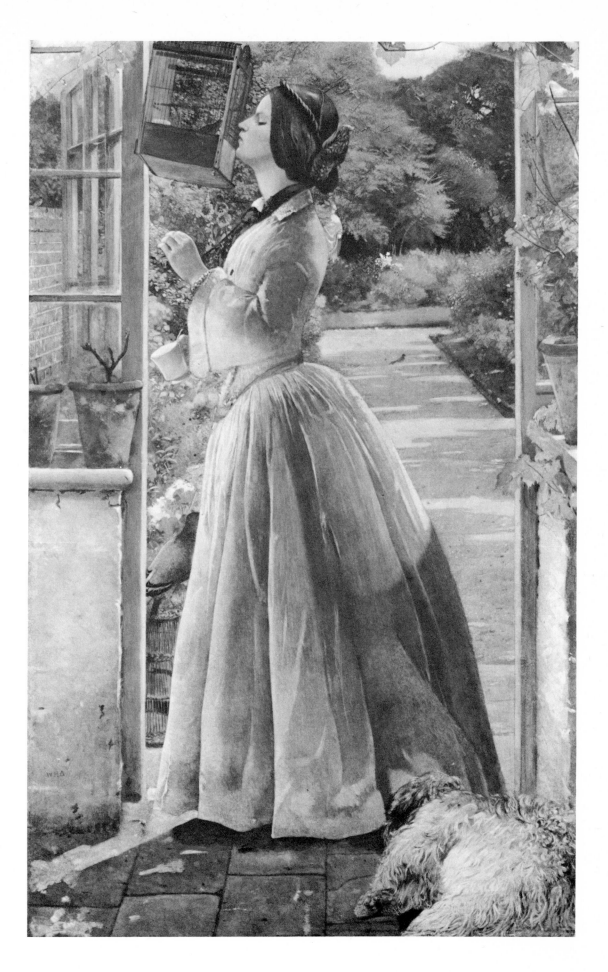

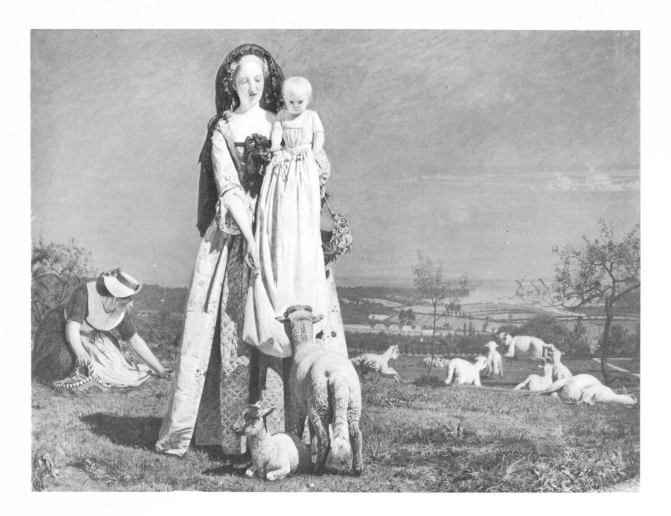

Ford Madox Brown (1821-93)
Pretty Baa Lambs. Oil on panel, 24" x 30", 1851-9. City of Birmingham Museum and Art Gallery. Painted in the open air at Stockwell in 1851, the landscape background was considerably altered in 1854 and 1859. Brown's wife, Emma, and daughter, Kate, sat for the figures; lambs and sheep were brought to Brown's studio from Clapham Common each morning.

William Holman Hunt (1827-1910)
Our English Coasts. Oil on canvas, 16¾",x 22¾", 1852. The Tate Gallery, London.
Praised by Ruskin for its "absolutely faithful balances of colour and shade by which actual sunlight might be transposed", the unnatural colours and extreme precision of detail bring the style almost beyond the limits of strict realism. Although as a group the Pre-Raphaelites did not paint pure landscapes, this picture stands as a pioneer work of 19th century outdoor naturalism.

William Holman Hunt (1827-1910)
The Scapegoat. Oil on canvas, 33¾" x 54½", 1854. The Lady Lever Art Gallery, Port Sunlight. Painted on the shore of the Dead Sea, *The Scapegoat* was an attempt to create a modern religious picture. Its subject, taken from the Talmud, is the goat which was ritually driven out of the temple into the wilderness on the Day of Atonement to carry off the sins of the people. The painting was received coldly by most of the critics when it was exhibited in 1856 and Ruskin said "it was a mere goat, with no more interest for us, than the sheep which furnished yesterday's dinner."

22

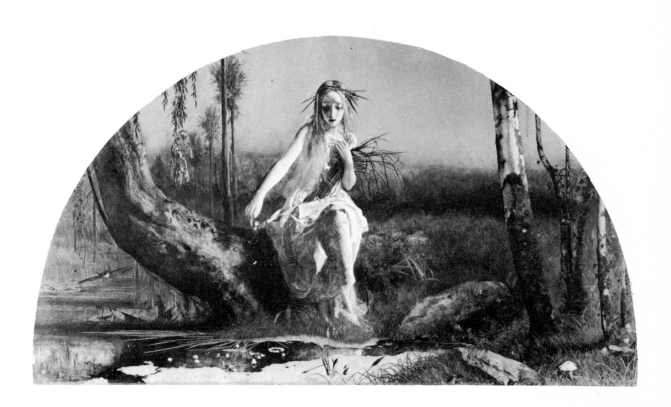

Arthur Hughes (1830-1915)
Ophelia. Oil on canvas, 27" x 48¾", 1852. Manchester City Art Gallery.
Hughes' first important painting was exhibited at the Royal Academy in 1852 with Millais' *Ophelia,* neither artist being aware they had chosen to paint the same subject until varnishing day.

Dante Gabriel Rossetti (1828-82)
Study for *Dante's Vision of Rachel and Leah.* Pencil, 13¾" x 6½", 1855. City of Birmingham Museum and Art Gallery.
This is a pencil study for the watercolour *Rachel,* done in the same year. The model was Elizabeth Siddal of whom Rossetti did many similarly exquisite pencil studies at this time.

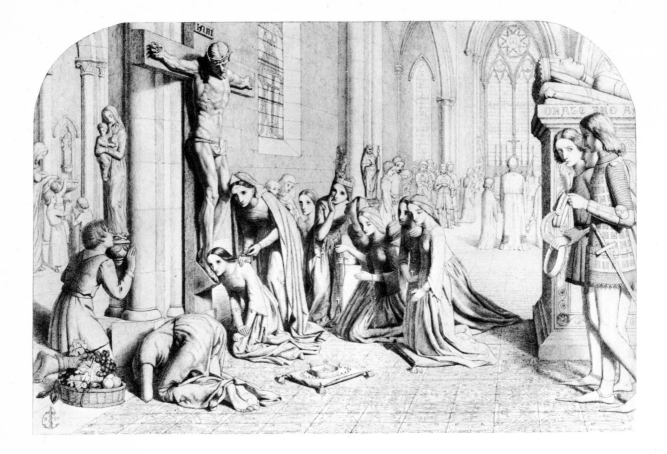

James Collinson (1825?-88)
Study for the oil painting *The Renunciation of Queen Elizabeth of Hungary.* Pen and ink, 12" x 17", 1850. City of Birmingham Museum and Art Gallery.
The inspiration for this, Collinson's most important work, was Kingsley's *Saint's Tragedy.* Queen Elizabeth is depicted in a chapel renouncing her children, relations and all luxuries, in imitation of Christ. Collinson was engaged at one time to Rossetti's sister Christina, the poet. He later became a Roman Catholic and joined a religious community from 1852-4. Nowadays he is the most neglected of the original brotherhood.

Charles Allston Collins (1828-73)
Study for *Convent Thoughts.* Pen and ink, 13" x 7¾", 1853. The Tate Gallery, London.
The large oil painting is now at the Ashmolean Museum, Oxford. Although there is an undeniable stiffness in the poses of Collin's figures, the colouring and detail of the oil version of this picture is excellent.

Ford Madox Brown (1821-93)
Christ Washing Peter's Feet. Oil on canvas, 46" x 52½", 1851-56. The Tate Gallery, London.
This painting was part of the trend that outraged critics in the late 40s and early 50s when artists, like Millais in *Christ in the House of His Parents* and Rossetti in *The Girlhood of Mary Virgin,* were attempting to make the Holy Family more ordinary and human by painting them engaged in humble activities.

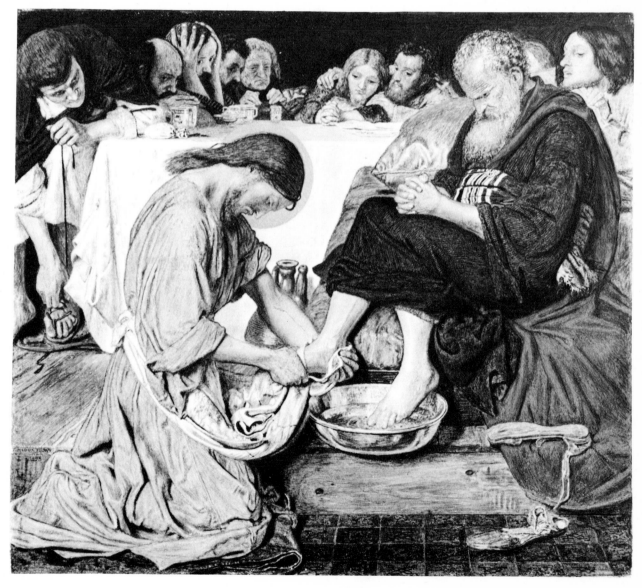

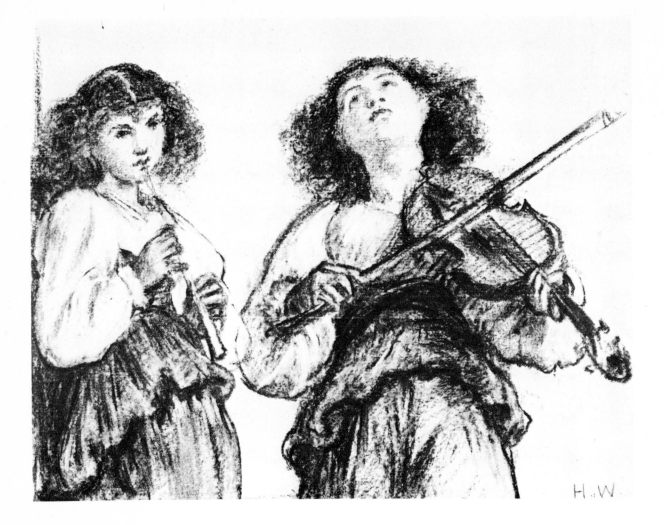

Henry Wallis (1830-1916)
Study of two girls in Italian costumes playing musical instruments. Black and white chalk, 8¼" x 10½", c. 1864. City of Birmingham Museum and Art Gallery.
Born in London, Henry Wallis studied at Cary's Academy of Art and also in Paris, Venice and Rome. He was influenced by the Pre-Raphaelites and his most famous work close to their style is *The Death of Chatterton* in the Tate Gallery.

Dante Gabriel Rossetti (1828-82)
The Maids of Elfenmere. 1854.
The original pen and ink design for this, the frontispiece of the poet William Allingham's *Day and Night Songs,* is now lost. When the poem was published in 1855, Burne-Jones, then at Oxford, said of this illustration "it is . . . the most beautiful drawing for an illustration I have ever seen. The weird faces of the Maids, the musical timed movement of their arms together as they sing, the face of the man above all, are such as only a great artist could conceive."

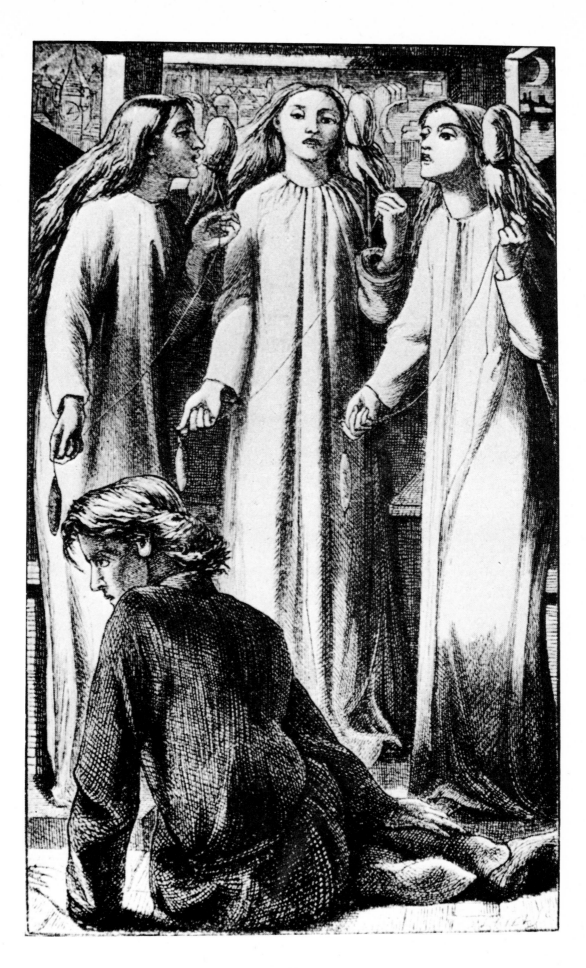

27

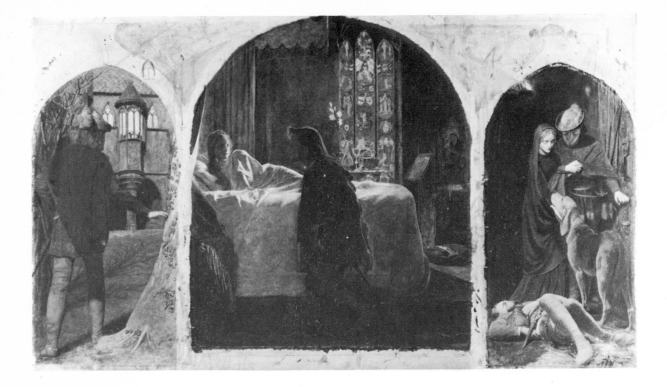

Arthur Hughes (1830-1915)
The Eve of St. Agnes. Oil on paper. Centre, 25¾" x 22½"; sides, each 23¼" x 11¾", 1856.
The Tate Gallery, London.
Hunt's 1848 painting was the prototype for Hughes' work, which uses the triptych form to relate
three scenes from Keat's poem - Porphyro's approach to the castle, the awakening of Madeline and,
as in Hunt's picture, their stealthy escape over the drunken porter.

John Everett Millais (1829-96)
Autumn Leaves. Oil on canvas, 41" x 29", 1856. City of Manchester Art Gallery.
Ruskin found Millais last Pre-Raphaelite picture "the most poetical" of all his works. In the autumn
of 1851 Millais, quoted by Hunt, spoke of the bittersweet concerns of the painting, which was
perhaps his greatest achievement: "Is there any sensation more delicious than that awakened by
the odour of burning leaves? To me nothing brings back sweeter memories of the days that are gone;
it is the incense offered by departing summer to the sky; and it brings one a happy conviction that
time puts a peaceful seal on all that is gone."

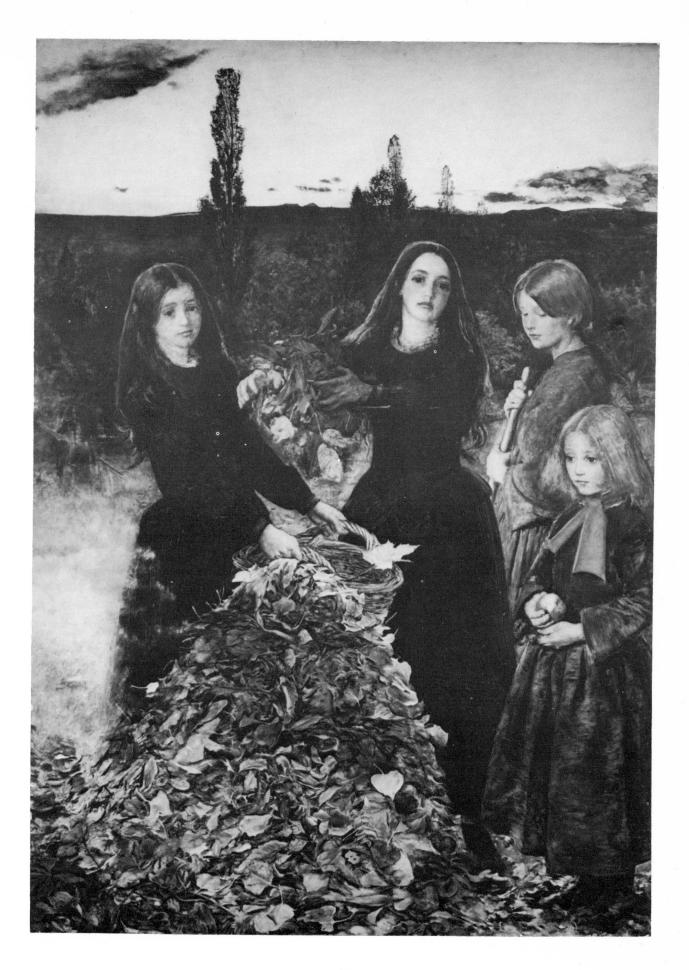

Ford Madox Brown (1821-93)
Study for *The Stages of Cruelty*. Watercolour, 5¾" x 4¾", 1856-90. The Tate Gallery, London. Although the large oil version, now at the City of Manchester Art Gallery, for which this is a study, was begun in 1856, work on it was left off in 1860 and was not begun again until 1887. Madox Brown completed it in 1890.

Arthur Hughes (1830-1915)
April Love. Oil on canvas, 35" x 19½", 1856. The Tate Gallery, London.
Arthur Hughes studied under Alfred Stevens and at the Royal Academy Schools. He was very impressed by Hunt's *The Eve of St. Agnes* at the 1847 exhibition and by the first number of the P.R.B's short-lived journal *The Germ* in 1850.
Of *April Love,* one of the most beautiful Pre-Raphaelite works, Ruskin said "Exquisite in every way; lovely in colour, most subtle in the quivering expression of the lips and sweetness of the tender face, shaken, like a leaf by winds upon its dew, and hesitating back into place."

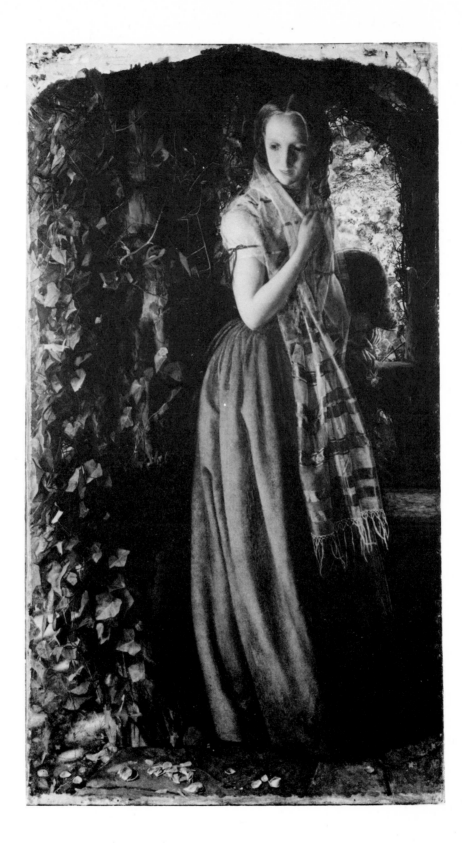

John Everett Millais (1829-96)
Illustration to *A Dream of Fair Women* from *Poems by Tennyson*, Edward Moxon, 1857.

John Everett Millais (1829-96)
The Blind Girl. Oil on canvas, 32" x 24½", 1856. City of Birmingham Museum and Art Gallery. The background of this picture was painted in Winchelsea in 1854 and the figures and some foreground in Perthshire where Millais had recently settled with his wife, Effie. The picture won the prize at the Liverpool Academy in 1857.

Overleaf:

Ford Madox Brown (1821-93)
An English Autumn Afternoon. Oil on canvas, 28¼" x 53", 1852-4. City of Birmingham Museum and Art Gallery.
The picture shows the view from the artist's lodgings at Hampstead looking towards Highgate. Brown had a great love for the English countryside and landscape was often an important part of his pictures. Indeed, he painted several pure landscapes.

Arthur Hughes (1832-1915)
The Long Engagement. Oil on canvas, 41½" x 20½", 1859. City of Birmingham Museum and Art Gallery.
Begun in 1853 as *Orlando in the Forest of Arden,* but rejected by the Royal Academy in 1855, Hughes later substituted the present figures for Orlando. The refinement of his approach and sensitivity to colour and texture are well illustrated by this exquisite work.

Dante Gabriel Rossetti (1828-82)
Beata Beatrix. Oil on canvas, 33" x 25½", 1877. City of Birmingham Museum and Art Gallery.
A replica of the 1864 version, this was left unfinished when Rossetti died and was later completed by Ford Madox Brown. Although not originally intended as such, it seems probable that Rossetti regarded the picture as a memorial to his wife. She had, in fact, sat for *Beatrix.*

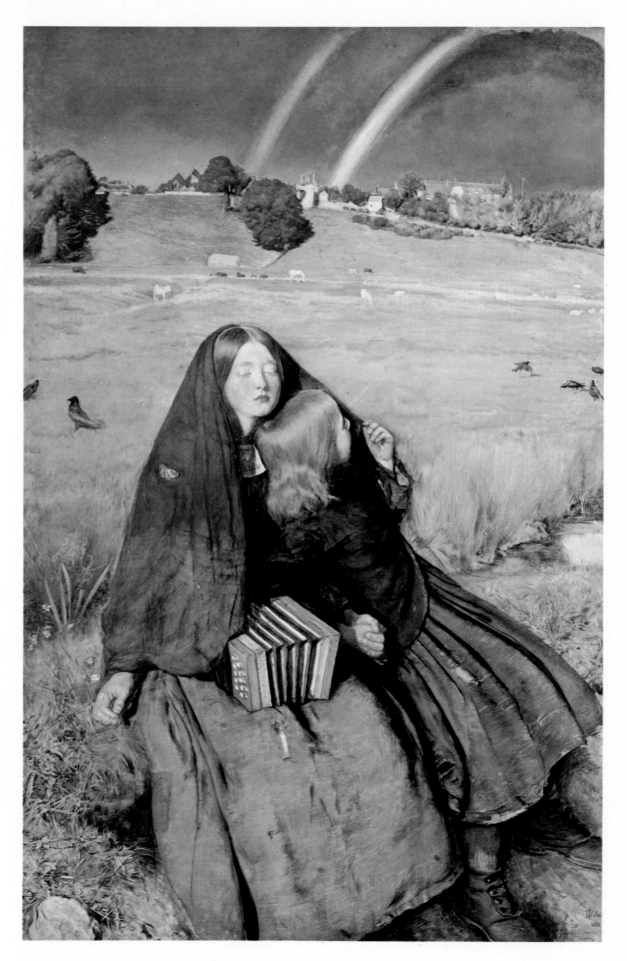

John Everett Millais The Blind Girl, 1856.

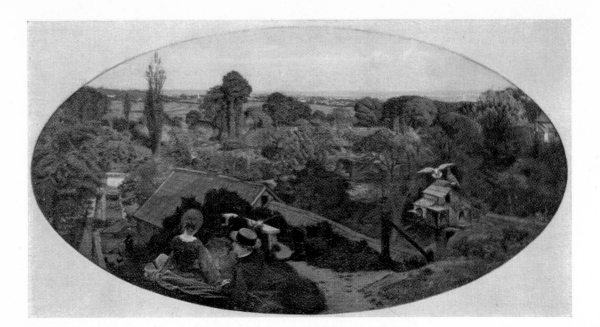

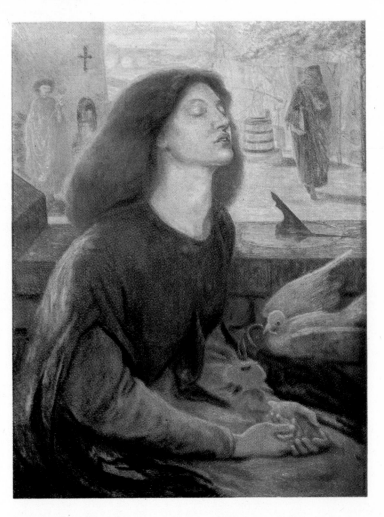

(*top*) **Ford Madox Brown** An English Autumn Afternoon, 1852–4.
(*left*) **Arthur Hughes** The Long Engagement, 1859.
(*above*) **Dante Gabriel Rossetti** Beata Beatrix, 1877.

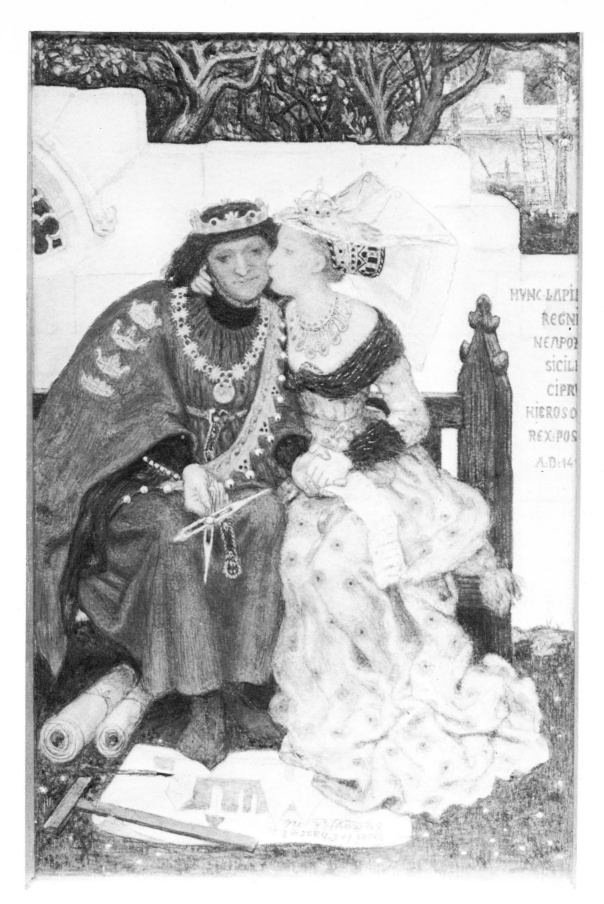

Ford Madox Brown (1821-93)
King Rene's Honeymoon. Watercolour, 10¼" x 6¾", 1864. The Tate Gallery, London.

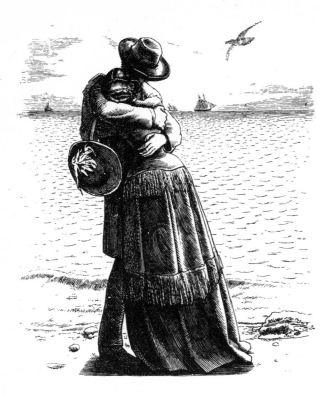

Above:
John Everett Millais (1829-96)
Illustration to *Locksley Hall* from *Poems by Tennyson,* Edward Moxon, 1857.

Top left:
William Holman Hunt (1827-1910)
Illustration to *The Lady of Shalott* from *Poems by Tennyson,* Edward Moxon, 1857.
Developed from an earlier design, *The Lady of Shalott* was the basis for an oil painting completed in 1905.

Top right:
William Holman Hunt (1827-1910)
Illustration to *The Ballad of Oriana* from *Poems by Tennyson,* Edward Moxon, 1857.

Bottom left:
Dante Gabriel Rossetti (1828-82)
St. Cecilia, illustration to *The Palace of Art* from *Poems by Tennyson,* Edward Moxon, 1857.

Bottom right:
William Holman Hunt (1827-1910)
Illustration to *Godiva* from *Poems by Tennyson,* Edward Moxon, 1857.

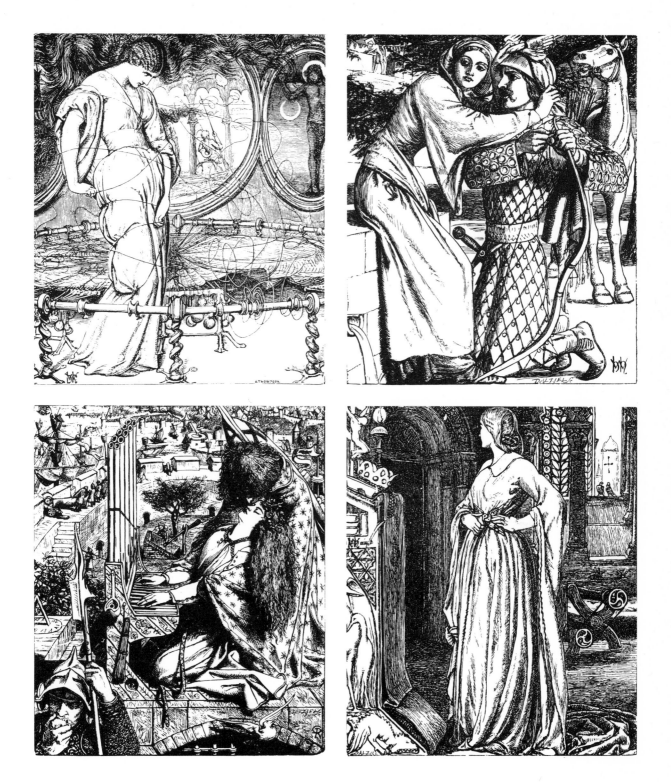

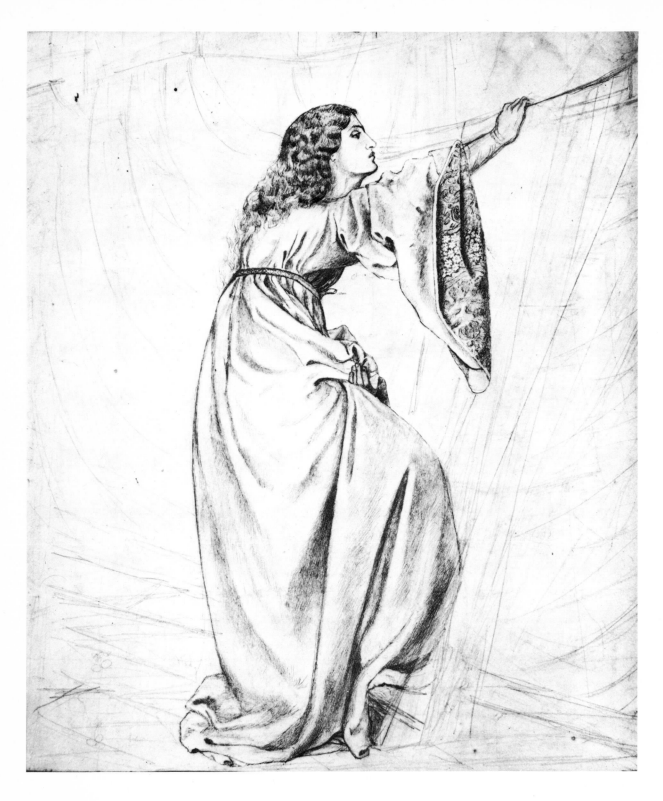

William Morris (1834-90)
Study for *Iseult on the Ship*. Pen and ink and pencil, 18½" x 15", 1857. William Morris Gallery, Walthamstow.

Under the strong influence of Rossetti in 1856, Morris initially intended to become a painter. He executed few pictures, however, always experiencing difficulty in drawing the human figure. The number of his figure designs for 'The Firm's' stained glass cartoons declined after the mid 1860's and ceased altogether in 1873.

The model for this picture was Jane Burden who was later to become Morris's wife.

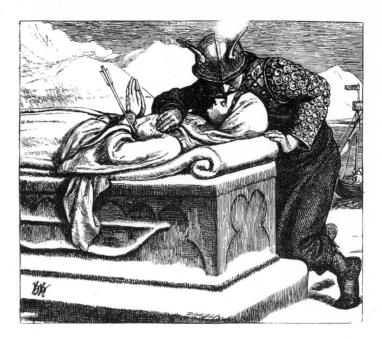

William Holman Hunt (1827-1910)
Illustration to the *Ballad of Oriana* from *Poems by Tennyson,* Edward Moxon, 1857.
Hunt worked on *Oriana* in 1856.

Dante Gabriel Rossetti (1828-82)
King Arthur and the Weeping Queens, illustration to *The Palace of Art* from *Poems by Tennyson,*
Edward Moxon, 1857.
Rossetti worked on four designs for the Moxon Tennyson in 1856-7.

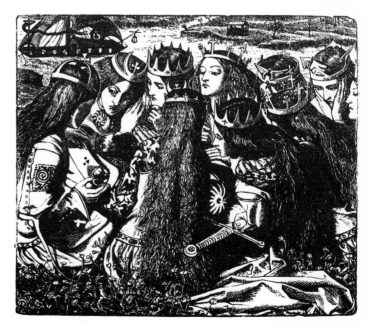

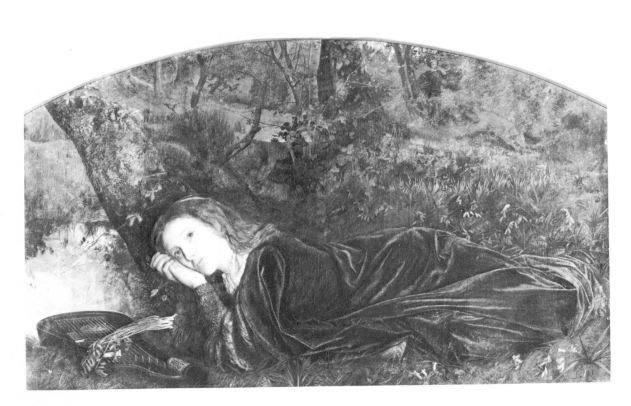

Arthur Hughes (1830-1915)
The Rift Within the Lute. Oil on canvas, 21½" x 36½", 1858. City Art Gallery, Carlisle.

William Lindsay Windus (1822-1901)
Too Late. Oil on canvas, 38" x 30", 1858. The Tate Gallery, London.
The most important of the Liverpool artists, Windus' enthusiasm for the London Brotherhood was responsible for making the Liverpool Academy into a lively centre for a group of minor painters in the 50s. *Too Late,* a sentimental painting on the theme of consumption and, perhaps, illegitimacy, and his second picture in the Pre-Raphaelite manner was attacked by Ruskin who said, "Something wrong here; either the painter has been ill, or his picture sent to the Academy in a hurry . . . in time you may be a painter, not otherwise." Windus virtually stopped painting twenty-seven years before his death and destroyed nearly all his works.

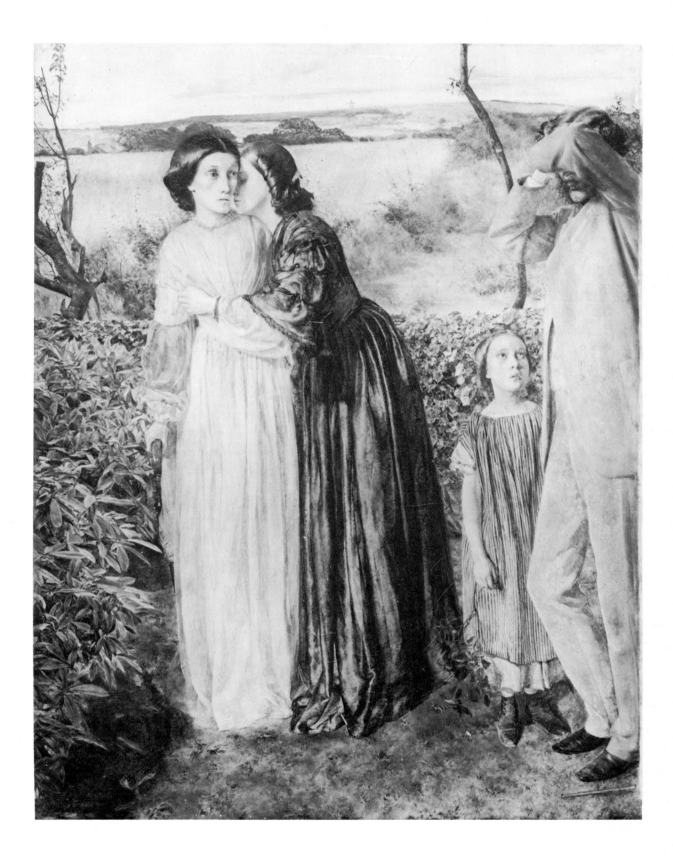

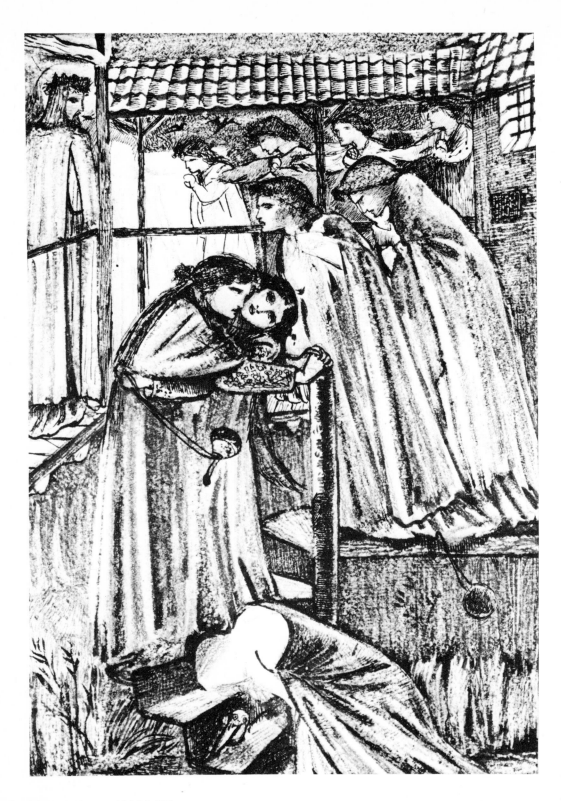

Edward Burne-Jones (1833-98)
Study for *The Parable of the Ten Virgins.* Pen and ink and pencil,c. 1859-60. Private Collection.
Burne-Jones, like his friend Morris under the spell of Rossetti, left Oxford in 1856 to become a
painter. He had had no art training and lacked the confidence to tackle oil or watercolours for
four or five years.
This picture is a study for one of the last and most accomplished of his pen and ink works.
Rossetti's influence is readily apparent in his early works, but Burne-Jones is always original and de-
velops his ideas further.·

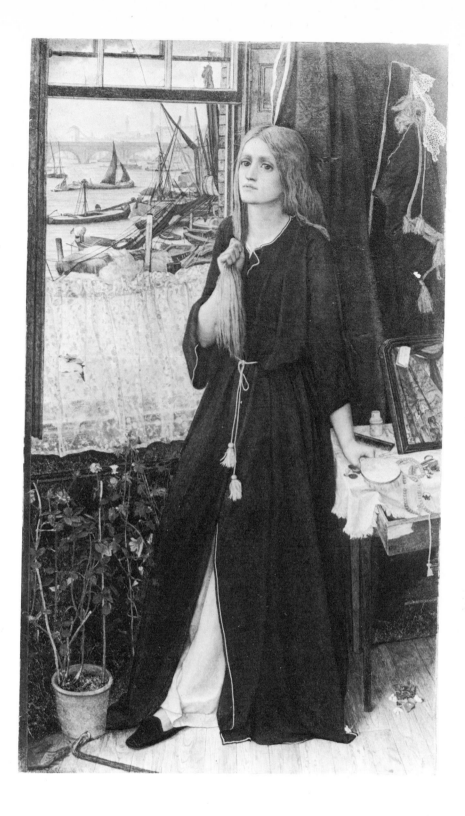

J. Roddam Spencer-Stanhope (1829-1908)
Thoughts of the Past. Oil on canvas, 34" x 20", 1859. The Tate Gallery, London.
Spencer-Stanhope was enlisted by Rossetti to paint one of the Oxford Union murals in 1857-8. He studied under G. F. Watts and Burne-Jones and was especially influenced by the latter. A considerable amount of his early work was for church decoration, commissions procured through G. F. Bodley, the gothic revival architect. He finally moved to Florence in 1880.

Simeon Solomon (1840-1905)
The Meeting of Dante and Beatrice. Pen and ink, 7¾" x 9", 1859-63. The Tate Gallery, London. This is an early work, clearly showing the influence of Rossetti and the Pre-Raphaelites on the artist. Solomon became a great friend of the poet Swinburne who had an unfortunate influence on him; he died in poverty in 1905. In his later work, the power of his drawing decreased as the mystical element in his work increased but this later work is still unfairly neglected, as, indeed, it was in his own time.

Arthur Hughes (1830-1915)
The Tryst. Aurora Leigh's Dismissal of Romney. Oil on canvas, 15¼" x 12", 1860. The Tate Gallery, London.

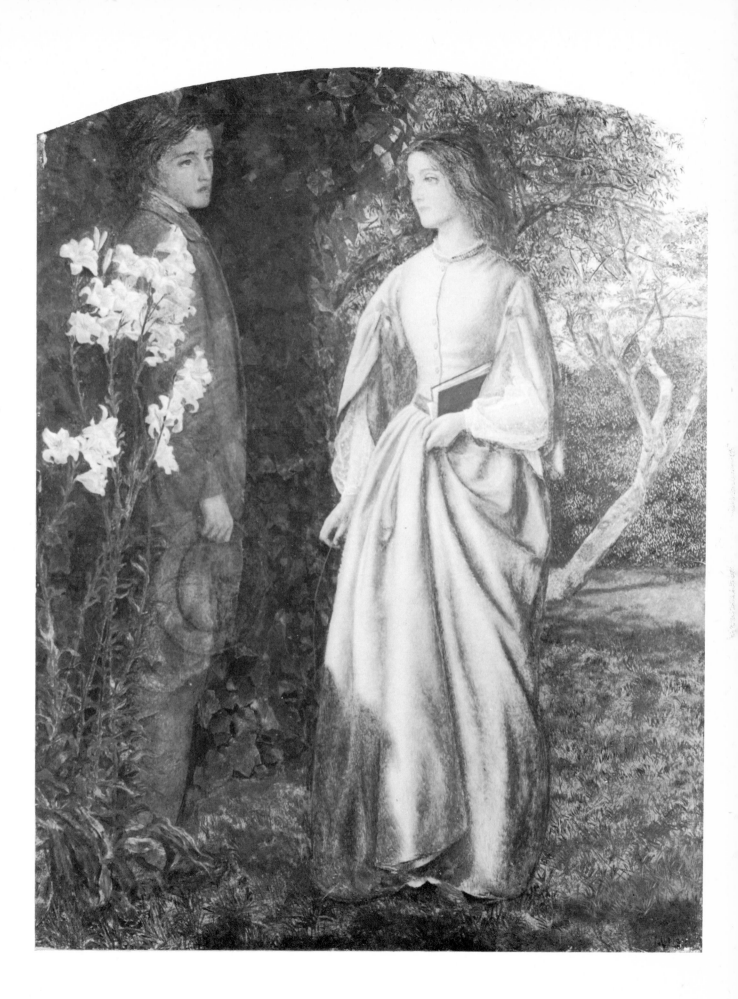

45

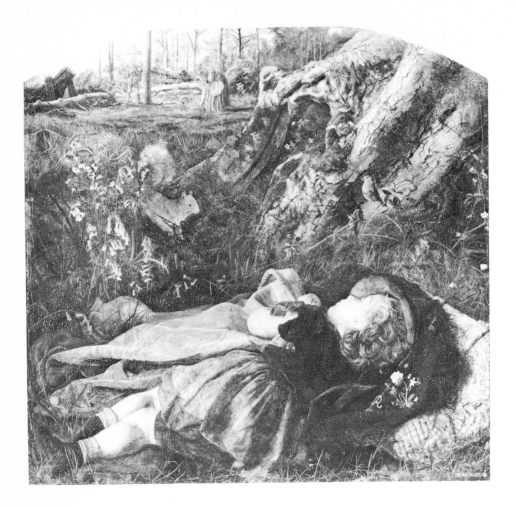

Arthur Hughes (1830-1915)
The Woodman's Child. Oil on canvas, 24" x 25¼", 1860. The Tate Gallery, London.

Arthur Hughes (1830-1915)
That was a Piedmontese Oil on mahogany, 16" x 12", 1862. The Tate Gallery, London.

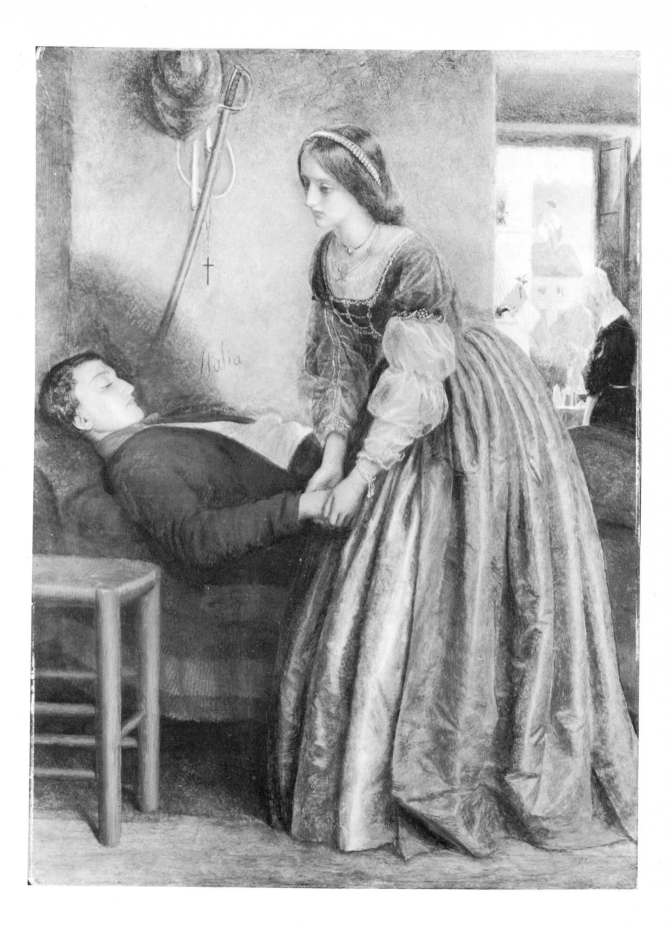

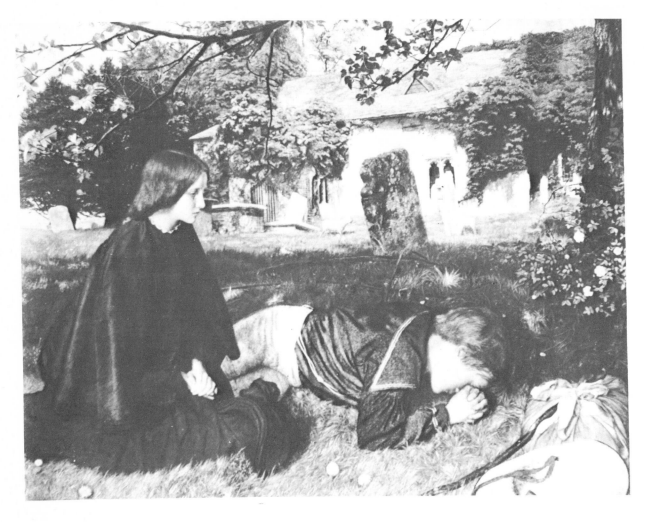

Arthur Hughes (1830-1915)
Home from the Sea. Oil on panel, 20" x 25¾", 1863. Ashmolean Museum, Oxford.
Painted out of doors on Pre-Raphaelite principles, Hughes' best known work has the sentimental narrative typical of so much Victorian art.

Ford Madox Brown (1821-93)
Take Your Son, Sir! Oil on canvas, 27¾" x 15", c. 1857. Unfinished. The Tate Gallery, London.
Brown was in severe financial difficulties when he began this picture, which remained both unsold and unfinished. It differs radically from most other Victorian illegitimacy paintings in the proud, defiant attitude of the mother, who seems to thrust her child and the responsibility for it at the spectator, rather than at the father, who can be glimpsed in the mirror. The direct and involving composition reflects Brown's realistic, straightforward approach to the "fallen woman" theme.

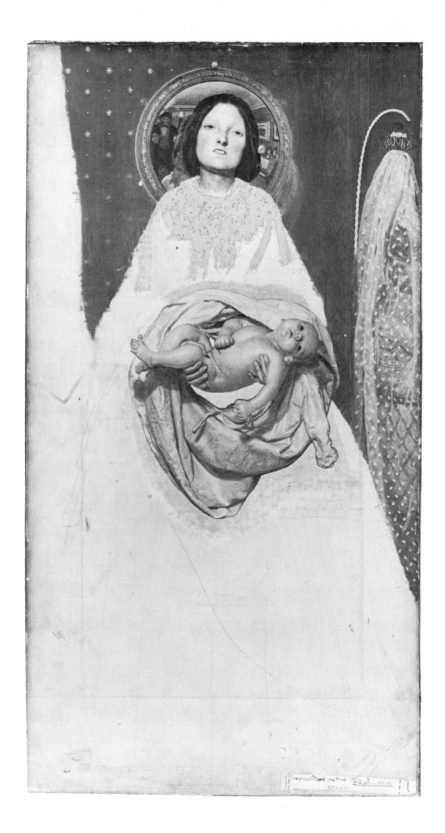

Joseph Noel Paton (1821-1901)
Illustration from *Lays of the Scottish Cavaliers and Other Poems* by W. E. Aytoun, 1863.
Paton, a Scot and friend of Millais, had a personal interpretation of Pre-Raphaelite principles which show in his early work.

William Holman Hunt (1827-1910)
The Two Gentlemen of Verona. Oil on canvas, 38¾" x 52½", 1851. City of Birmingham Museum and Art Gallery.
The Times' critical abuse of Hunt's brilliant painting led directly to Ruskin's famous letters in defence of the Pre-Raphaelite Brotherhood.

Edward Burne-Jones (1833-98)
The Star of Bethlehem. Watercolour, 101" x 152", 1888-91. City of Birmingham Museum and Art Gallery.
The Byzantine influence, the emphasis on verticals and long attenuated figures in Burne-Jones' later work is exemplified in this enormous watercolour based on a design for a Morris & Co. *Arras* tapestry, *The Adoration of the Magi.*

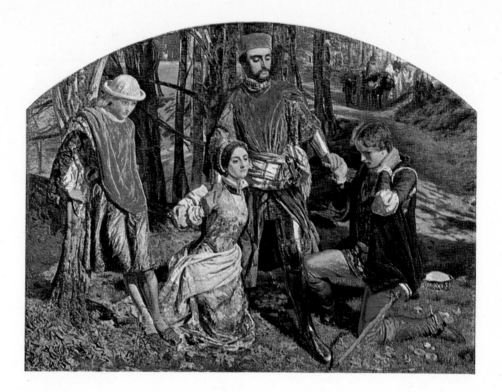

William Holman Hunt The Two Gentlemen of Verona, 1851.

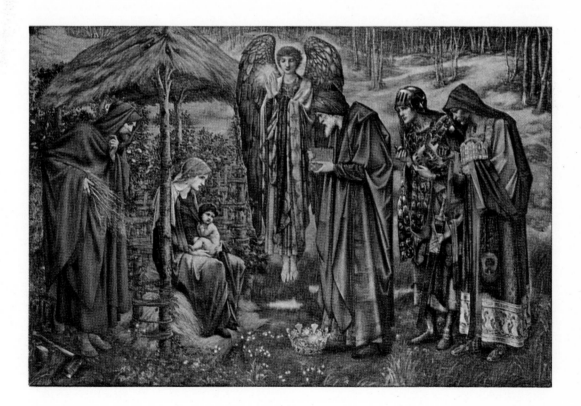

Edward Burne-Jones The Star of Bethlehem, 1889–91.

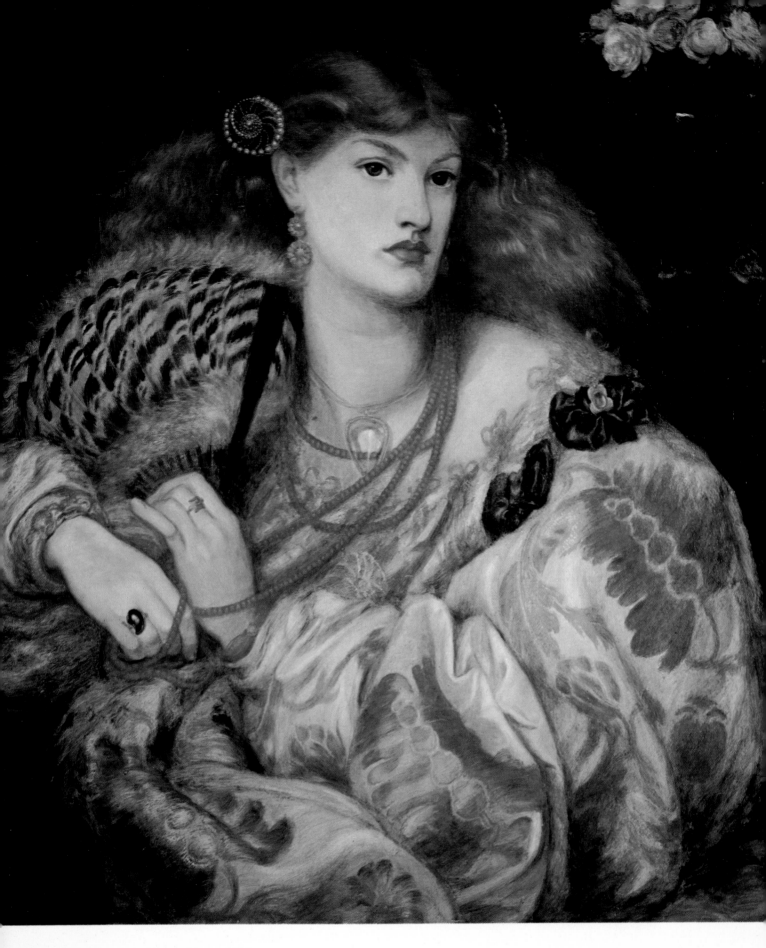

Dante Gabriel Rossetti Monna Vanna, 1866.

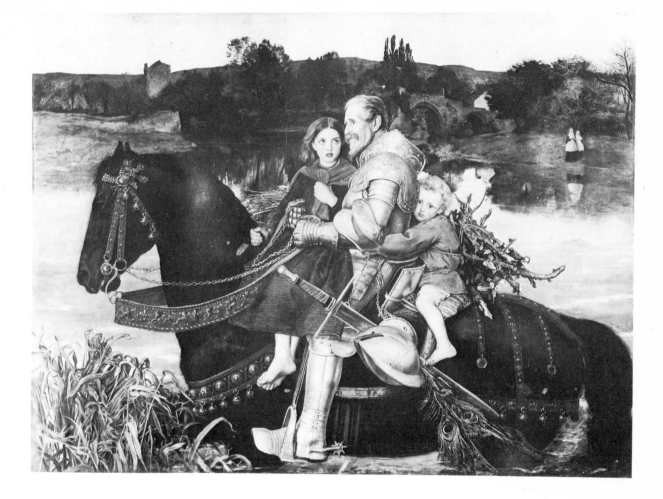

John Everett Millais (1829-96)
Sir Isumbras at the Ford. Oil on canvas, 49" x 67", 1857. The Lady Lever Art Gallery, Port Sunlight.
Ruskin was impatient with the abstruse meaning of this picture and what he felt to be its technical deficiencies. Painted during the final phase of Millais' career as a Pre-Raphaelite, it is now considered to be one of the first examples of symbolist art.

Dante Gabriel Rossetti (1828-82)
Monna Vanna. Oil on canvas, 35" x 34", 1866. The Tate Gallery, London.

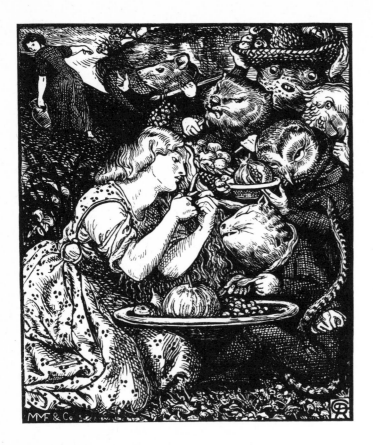

Dante Gabriel Rossetti (1828-82)
Frontispiece to *Goblin Market and Other Poems* by Christina Rossetti, Macmillan & Co., 1862.

Dante Gabriel Rossetti (1828-82)
St. George and Princess Sabra. Watercolour, 20¾" x 12", 1862. The Tate Gallery, London.
Elizabeth Siddal, who married Rossetti in 1860, sat for the Princess just a few days before she died.
The painting shows St. George washing his hands after having slain the dragon.

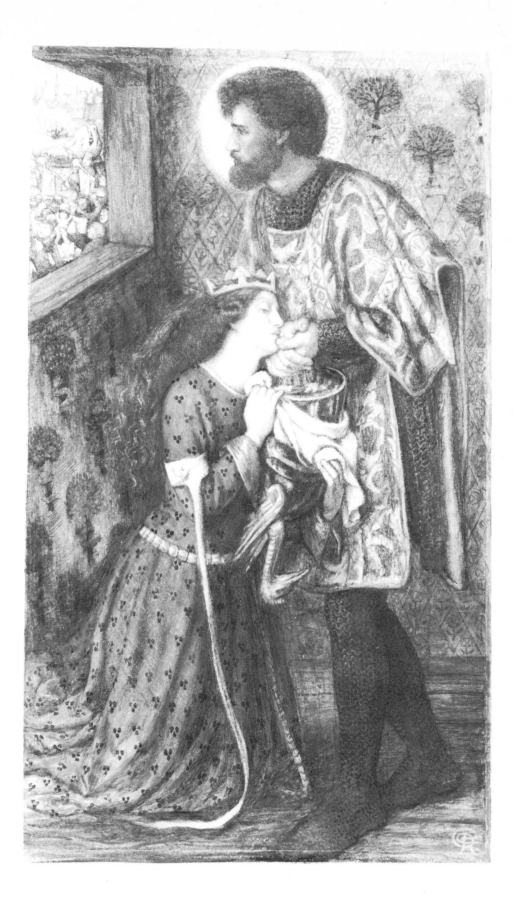

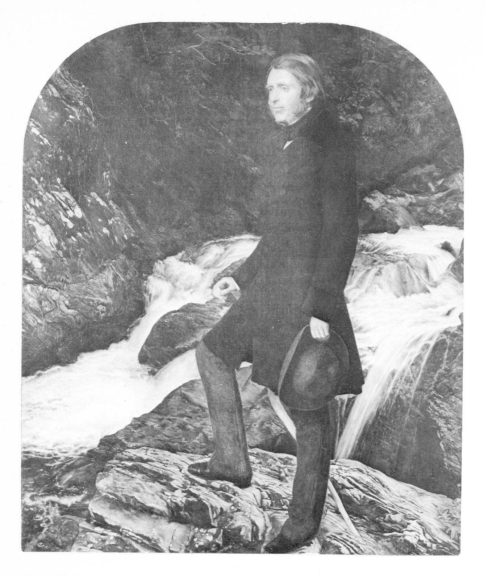

John Everett Millais (1829-96)
John Ruskin. Oil on canvas, 31" x 26¾", 1854. Private Collection.
Begun while visiting Ruskin in Glenfinlas, Scotland, July, 1853 and completed in London the next year, the accurate background demonstrates Ruskin's realistic, scientific theories of painting.

Ford Madox Brown (1821-93)
Work. Oil on canvas, 54½" x 77¼", 1852-65. Manchester City Art Gallery.
The most ambitious of all socially-conscious Pre-Raphaelite paintings, *Work* was done in the manner of a Renaissance ceiling or wall painting, although on a disproportionately small scale. The figures convey morality in terms of a 19th century preoccupation - the dignity, necessity and apportion of labour. The scene, still recognizable today, is Heath Street in Hampstead. The two figures on the right are the "brain workers" F. D. Maurice, founder of the Working Men's College, and Thomas Carlyle, who was painted from a photograph.

Ford Madox Brown (1821-93)
Walton-on-the-Naze. Oil on canvas, 12½" x 16½", 1859-60. Birmingham City Museum and Art Gallery.
Brown's innovative use of pinks and reds in a group of landscapes he painted during the 1850s in the countryside around London contributed much to the freeing of colour from conventional formulae.

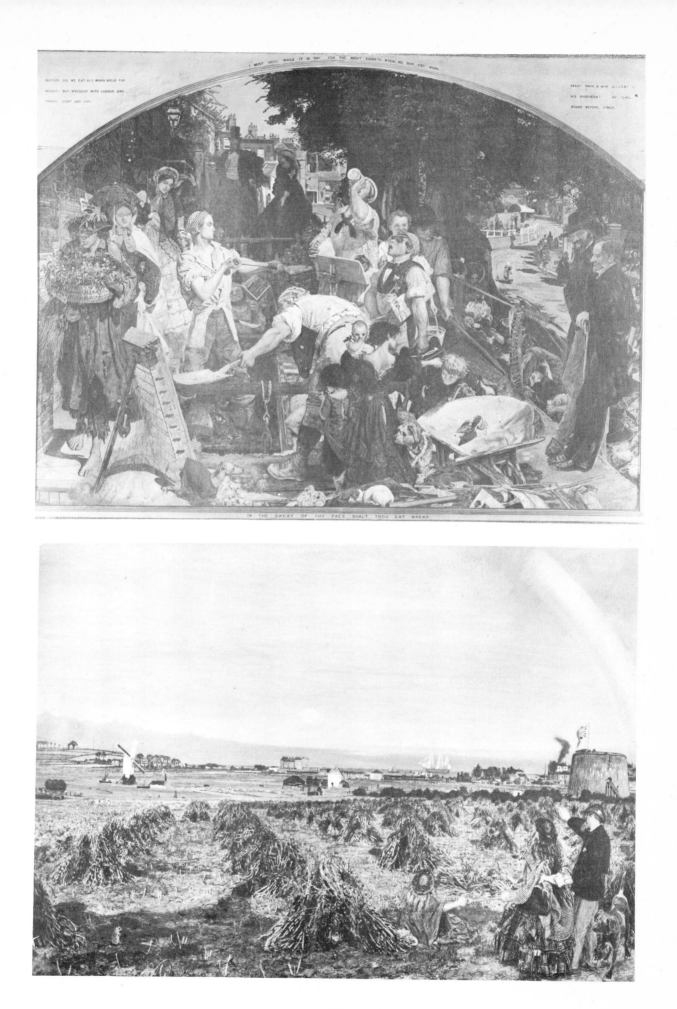

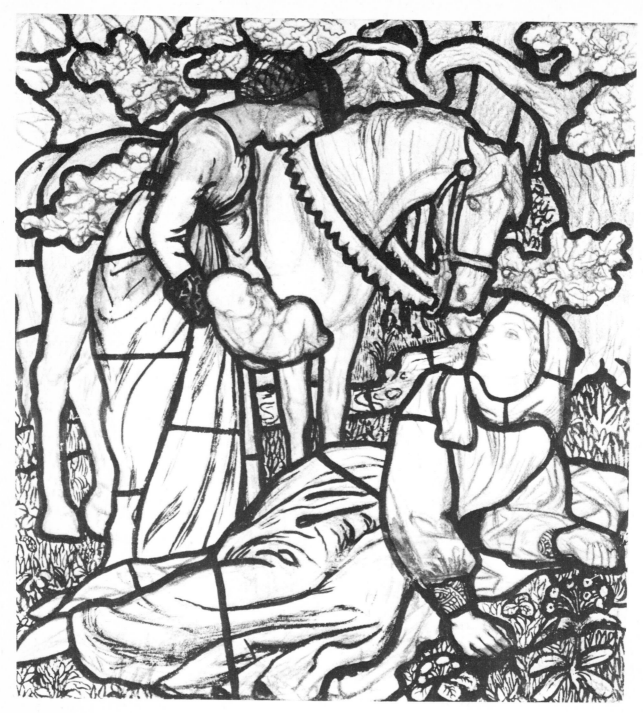

Arthur Hughes (1830-1915)
The Birth of Tristram: stained-glass design. Red chalk and Indian ink wash, 24½" x 23", 1862.
City of Birmingham Museum and Art Gallery.
This was Hughes' only stained glass design and his only work for 'The Firm'.

Edward Burne-Jones (1833-98)
Two angels playing harps: stained-glass design. Indian ink and sepia, 41" x 20½", 1862. City of
Birmingham Museum and Art Gallery.
This design, for the east window of Lyndhurst Church, Hampshire, is one of a very fine series in
that church designed by Burne-Jones and made by Morris, Marshall, Faulkner & Co. in 1862-3.

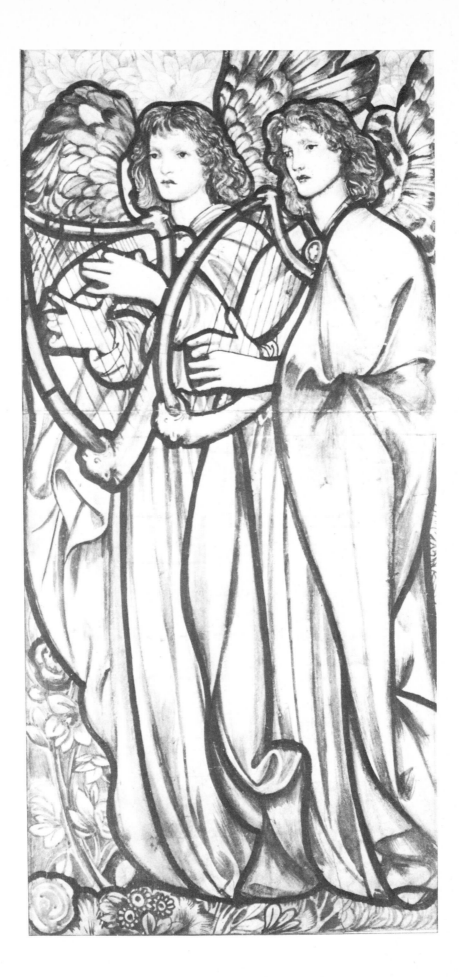

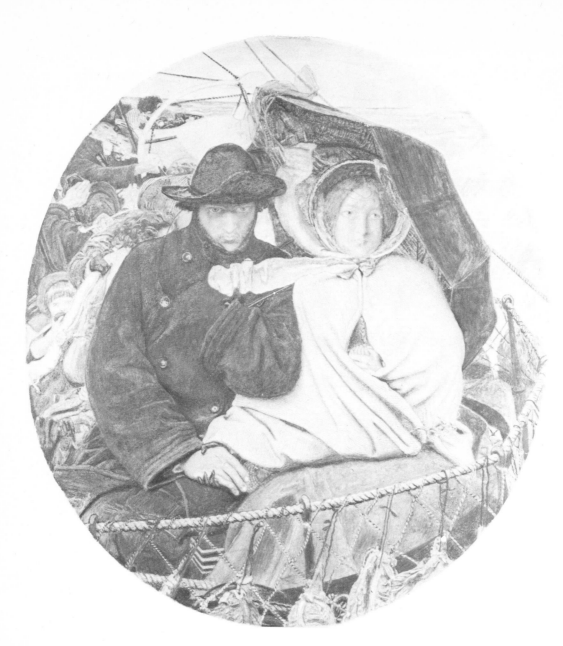

Ford Madox Brown (1821-1893)
The Last of England. Watercolour, 13" diam. 1864-6. The Tate Gallery, London.
This is a small replica of the oil of 1855 now at the City of Birmingham Museum and Art Gallery.
The subject was inspired by the emigration of Woolner, one of the P.R.B., to Australia in 1852.

Anthony Frederick Augustus Sandys (1829-1904)
Morgan Le Fay. Oil on panel, 24¾" x 17½", 1864. City of Birmingham Museum and Art Gallery.
Originally Sandys studied art under his father and teachers in his native Norwich. He exhibited at
the R.A. from 1851-1886. He met Rossetti in 1857 and the two friends lived together in 1860.

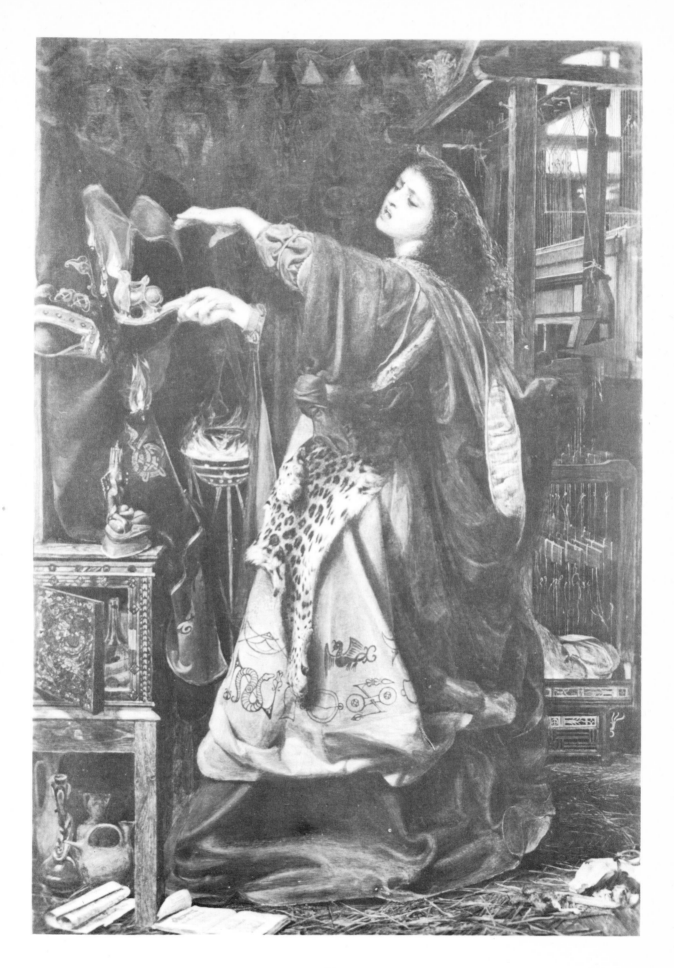

61

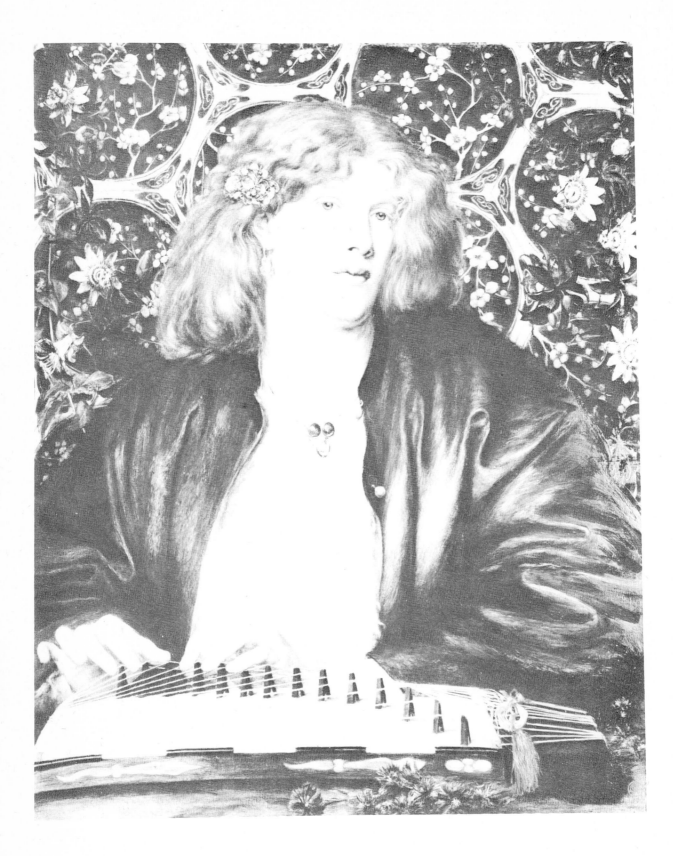

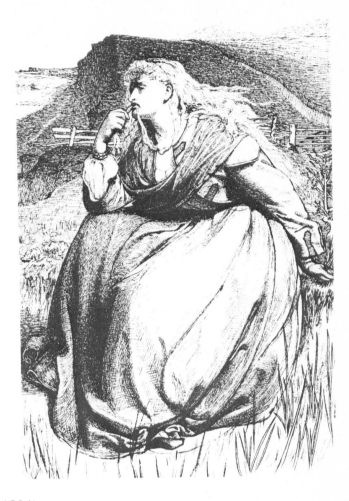

Anthony Frederick Augustus Sandys (1829-1904)
If, illustration to a poem by Christina Rossetti from *The Argosy.* Pen and brush with Indian ink, 6¼" x 4½", 1866. City of Birmingham Museum and Art Gallery.
Rossetti's influence is obvious in this drawing, one of the many Sandys produced for periodicals in the 1860s.

 Dante Gabriel Rossetti (1828-82)
The Blue Bower. Oil on canvas, 35½" x 27¼", 1865. The Barber Institute of Fine Arts, University of Birmingham.

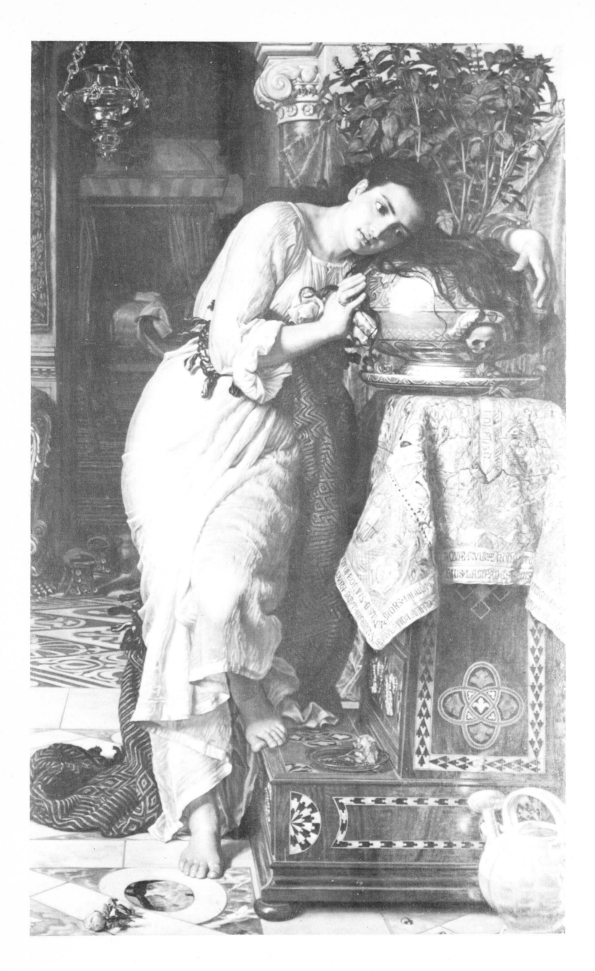

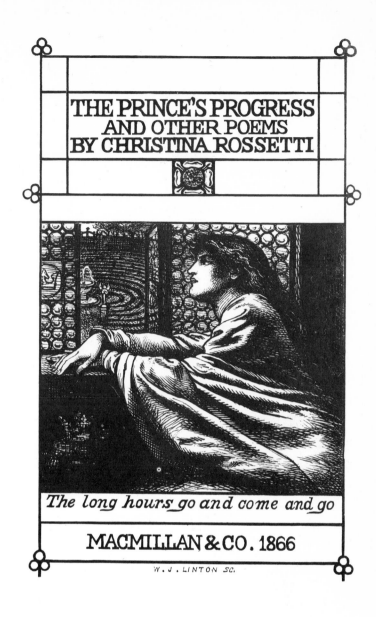

Dante Gabriel Rossetti (1828-82)
Title page to *The Prince's Progress and Other Poems* by Christina Rossetti, Macmillan & Co., 1866.

William Holman Hunt (1827-1910)
Isabella and the Pot of Basil. Oil on canvas, 72½" x 44½", 1867. Laing Art Gallery, Newcastle upon Tyne.
The scene illustrated from Keat's poem is of the macabre type that fascinated Hunt. Isabella's tears are watering the pot of basil in which Lorenzo's head has been buried.

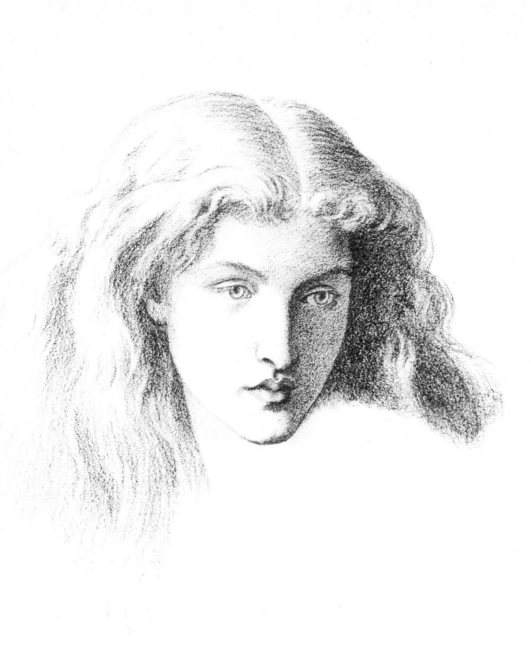

Dante Gabriel Rossetti (1828-82)
Head study: possibly May Morris. Coloured chalks, 1874. City of Birmingham Museum and Art Gallery.
Rossetti had overcome most of his technical difficulties by the 1870s. This is one of many fine chalk studies from the period.

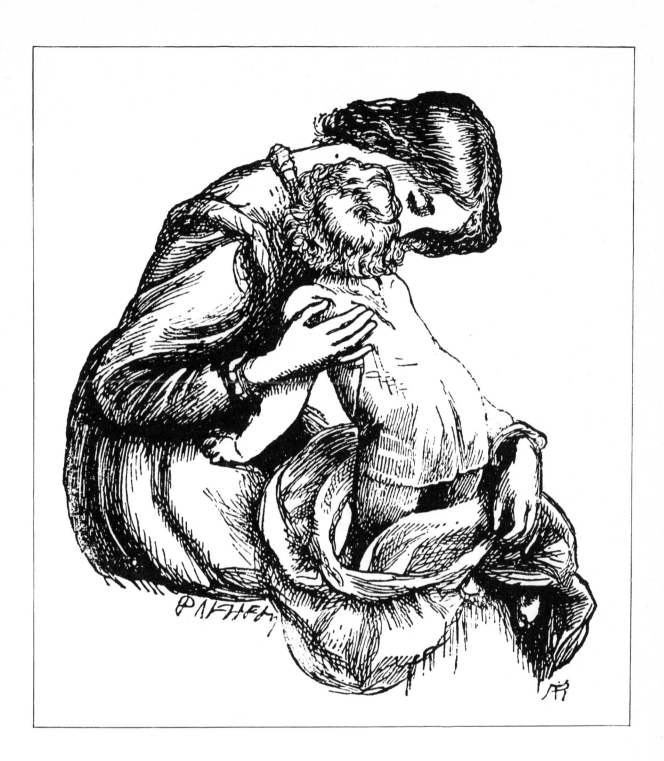

Arthur Hughes (1830-1915)
Illustration to *Sing Song* by Christina Rossetti, 1870.
One of the many book illustrations by Hughes during the 1850s-70s. After the 70s, Hughes was to concentrate more on genre subjects and landscapes, often retaining the sweetness of his earlier work but usually lacking some of the force.

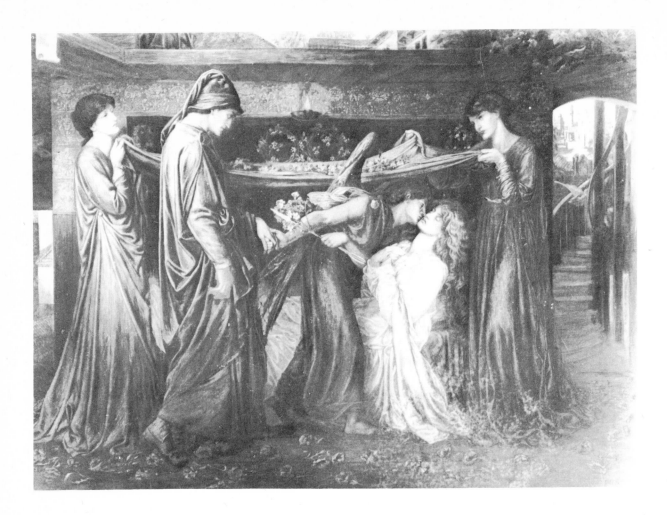

Dante Gabriel Rossetti (1828-82)
Dante's Dream at the Time of the Death of Beatrice. Oil on canvas, 83" x 125", 1871. Walker Art Gallery, Liverpool.
Rossetti's largest work, a replica of an 1856 watercolour, illustrates Dante's vision of Beatrice's death in the *Vita Nuova.* Jane Morris modelled for Beatrice.

Edward Burne-Jones (1833-98)
The Beguiling of Merlin. Oil on canvas, 73" x 43½", 1874. The Lady Lever Art Gallery, Port Sunlight.

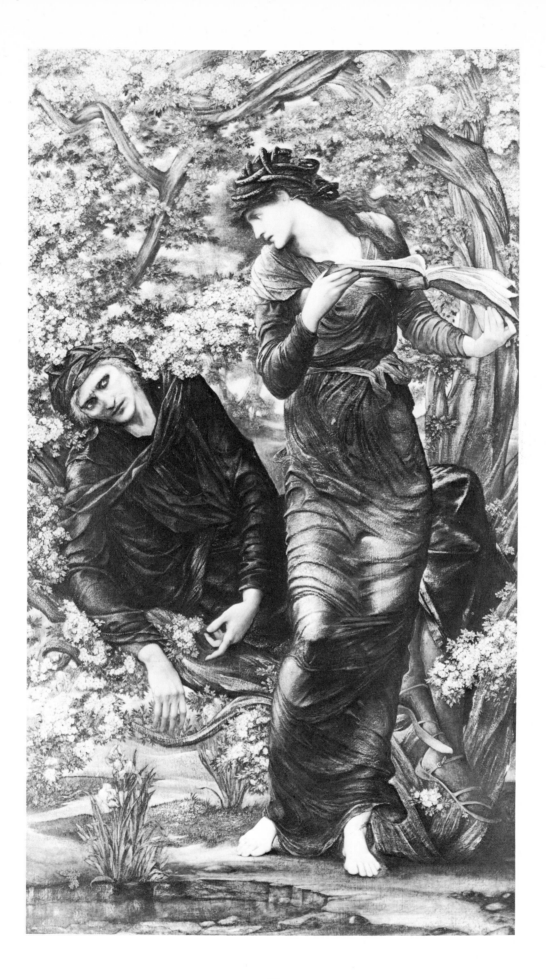

71

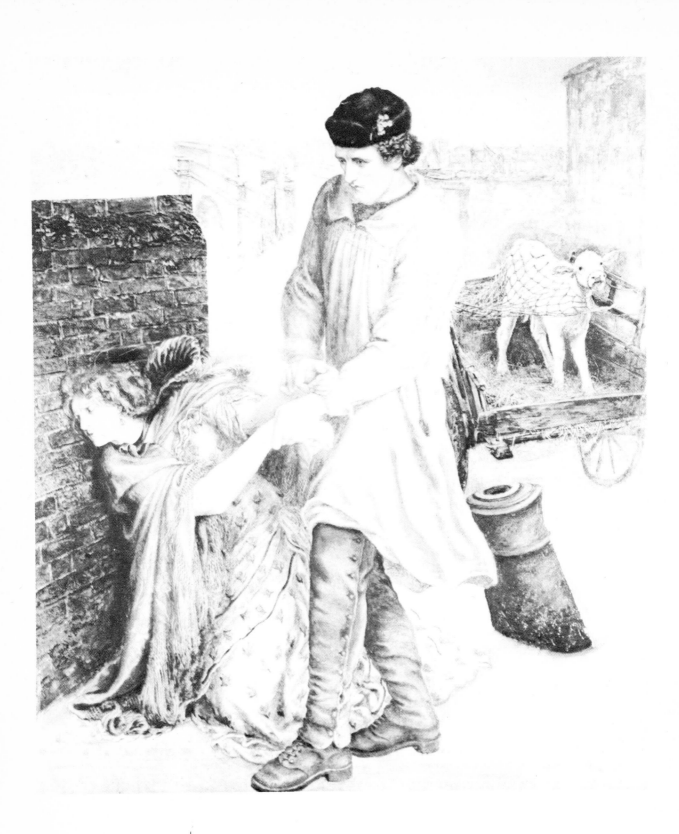

Dante Gabriel Rossetti (1828-82)
Found. Oil on canvas, 36" x 31½", begun 1854. Samuel and Mary R. Bancroft Collection, Delaware Art Museum.
Rossetti never completed his only "modern picture", though he worked on it intermittently until his death. He could not overcome the technical problems of the perspective or the incompatibility of the moral, realistic subject.

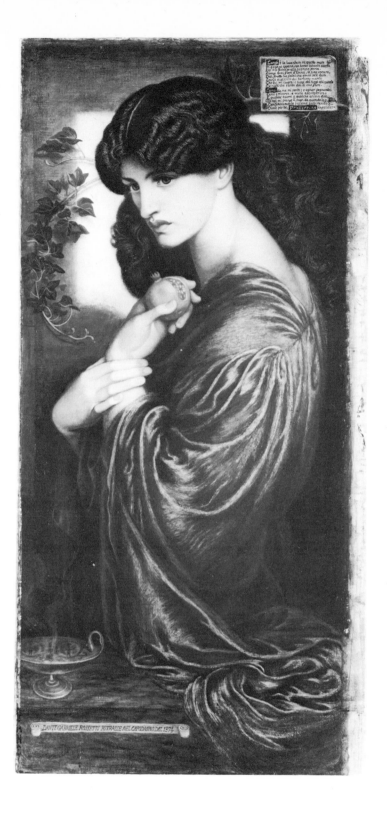

Dante Gabriel Rossetti (1828-82)
Proserpine. Oil on canvas, 49¾" x 24", 1874. The Tate Gallery, London.
One of eight versions of *Proserpine,* this was a replica painted for one of the artist's important patrons, the shipowner F. F. Leyland. The model was Jane Morris and the picture a particular favourite of Rossetti's.

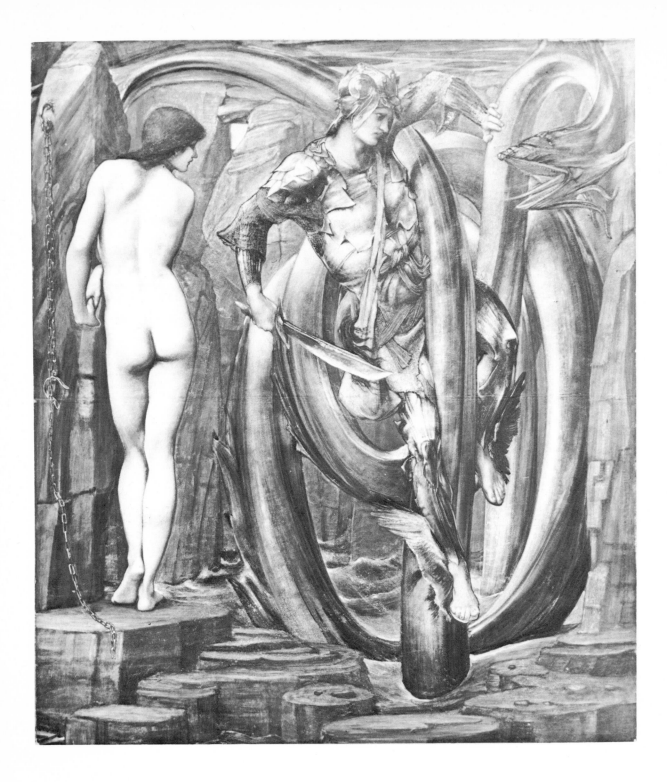

Edward Burne-Jones (1833-98)
Perseus Slaying the Sea Serpent. Oil on canvas, 60½" x 54½", c. 1875-1877. Southampton City Art Gallery.
Part of the *Perseus* series, this painting shows the influence of Michaelangelo and Fuseli. In typical Burne-Jones style movement is created by contrasting the static figures with bold slashing lines and coils.

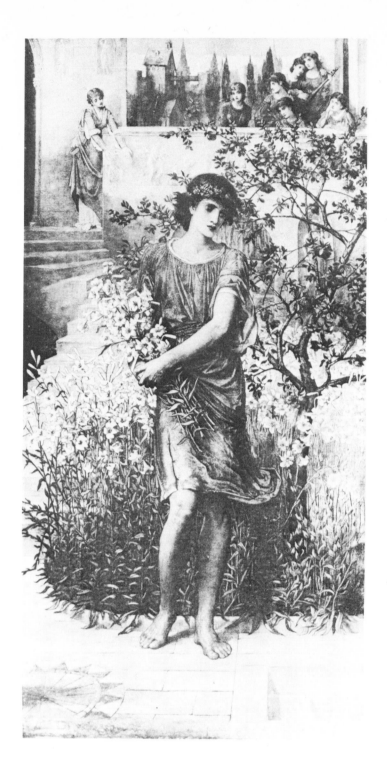

John Melhuish Strudwick (1849-1935)
My Beloved is gone down to his Garden. Oil on canvas, 28" x 15", 1879. Private Collection.
A pupil of both Spencer-Stanhope and Burne-Jones, Strudwick inherited several characteristics of
the latter. He painted gentle, sweet pictures with a jewel-like surface resulting from his meticulous
attention to detail. His technical limitations meant that he would spend a great length of time on
each picture and consequently his output was relatively small.

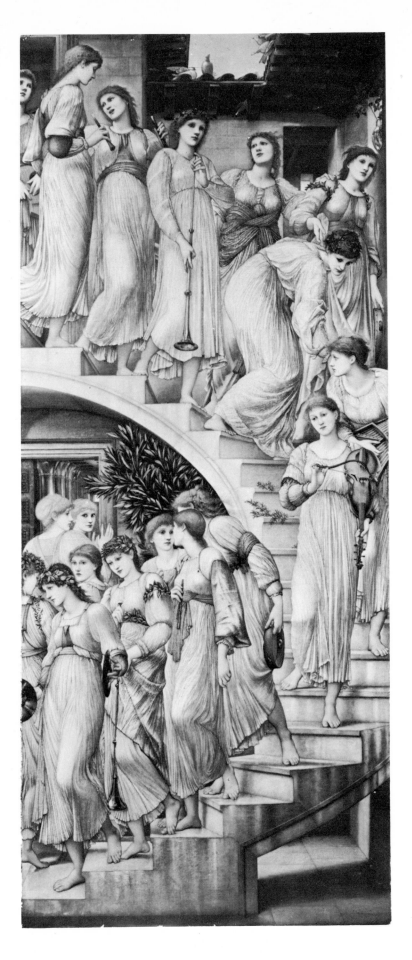

76

William Holman Hunt (1827-1910)
The Triumph of the Innocents. Oil on canvas, 61½" x 100", 1883-84. The Tate Gallery, London.
This, the major painting of Hunt's last years, was begun in Jerusalem in 1871 but remained unfinished for more than ten years. Not in the vein of Hunt's earlier moral rationalism, the painting exemplifies his late belief that exacting naturalism, while a necessary step in attaining visual truth, was not be considered finally obligatory.

Edward Burne-Jones (1833-98)
The Golden Stairs. Oil on canvas, 109" x 46", 1880. The Tate Gallery, London.
As in *King Cophetua and the Beggar Maid,* Burne-Jones used a vertically divided "S" shaped composition in this painting. Probably inspired by Blake's *The Dream of Jacob,* it exemplifies Burne-Jones' idealistic art with its deep concern for design and insubstantial expressionless figures.

Simeon Solomon (1840-1905)
Twilight, Pity and Death. Crayon, 12½" x 11¼", 1889. City of Birmingham Museum and Art Gallery.
A typical example of Solomon's later mystical-aesthetic style.

Edward Burne-Jones (1833-98)
The Countess of Plymouth. Oil on canvas, 78½" x 37", 1893. National Museum of Wales, Cardiff, reproduced by permission of the Earl of Plymouth.

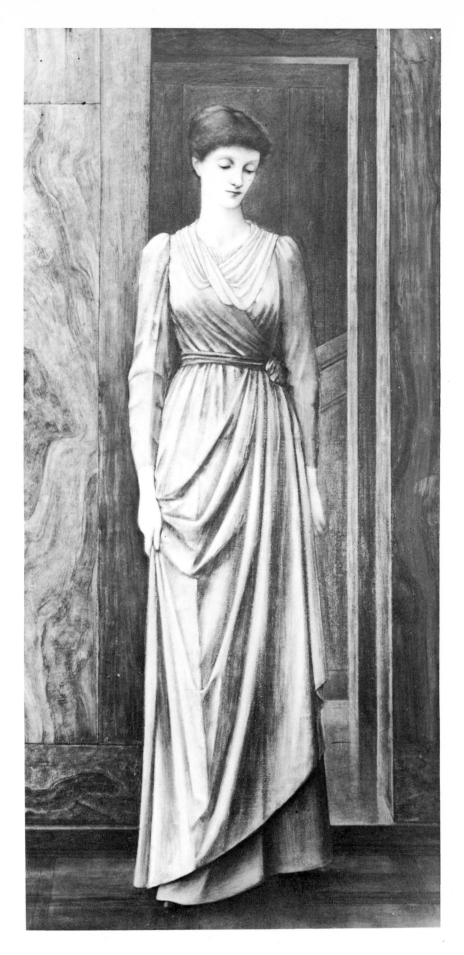

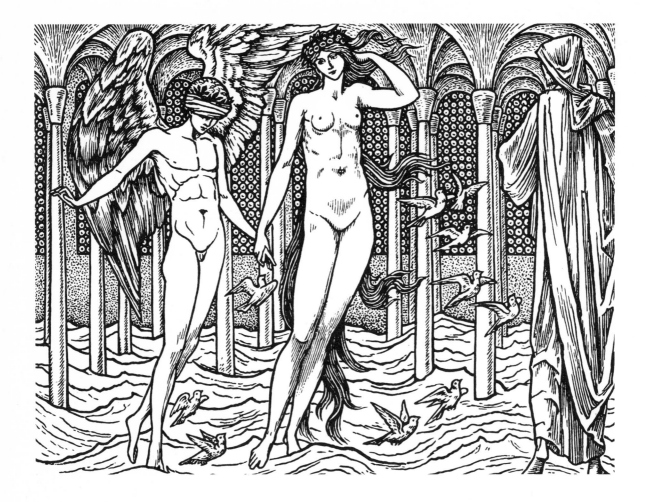

Edward Burne-Jones (1833-98)
The Knight's Tale, illustration for the Kelmscott Chaucer, 1894.
The finest book produced by William Morris's Kelmscott Press, the *Chaucer* was designed by
Morris and had eighty-seven woodcut illustrations by Burne-Jones.

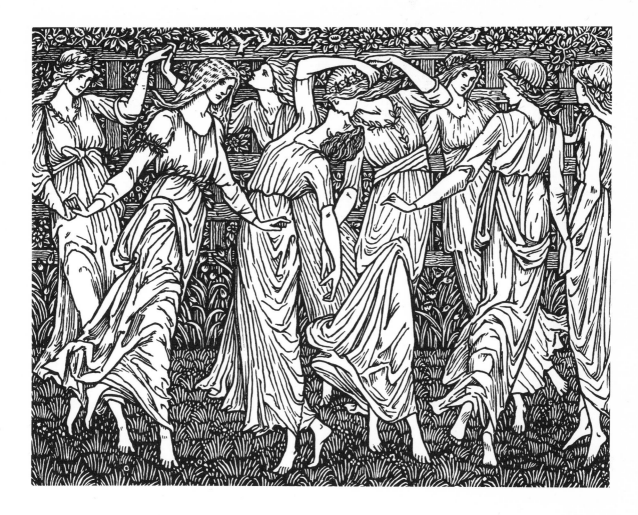

Edward Burne-Jones (1833-98)
The Romance of the Rose, illustration for the Kelmscott Chaucer, 1894.

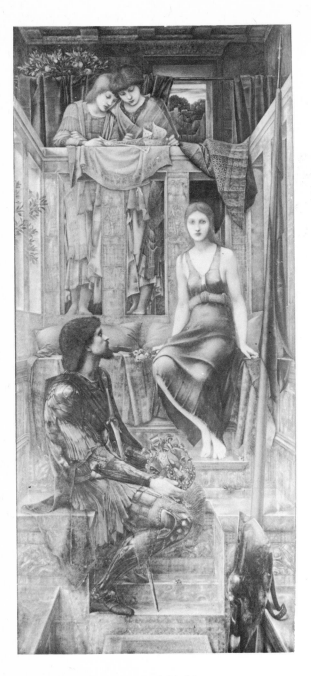

Edward Burne-Jones (1833-98)
King Cophetua and the Beggar Maid. Oil on canvas, 115½" x 53½", 1884. The Tate Gallery, London.

William Holman Hunt (1827-1910)
The Lady of Shalott. Oil on canvas, 74" x 75½", c. 1886-1905. The Wadsworth Athenaeum, Hartford, Connecticut.
A truly Pre-Raphaelite picture, this late painting, filled with oriental details, was completed more than fifty years after the formation of the Brotherhood. Developed from an 1850 drawing and the illustration for Moxon's *Tennyson,* it shows the influence of the flowing style of Rossetti and Burne-Jones.

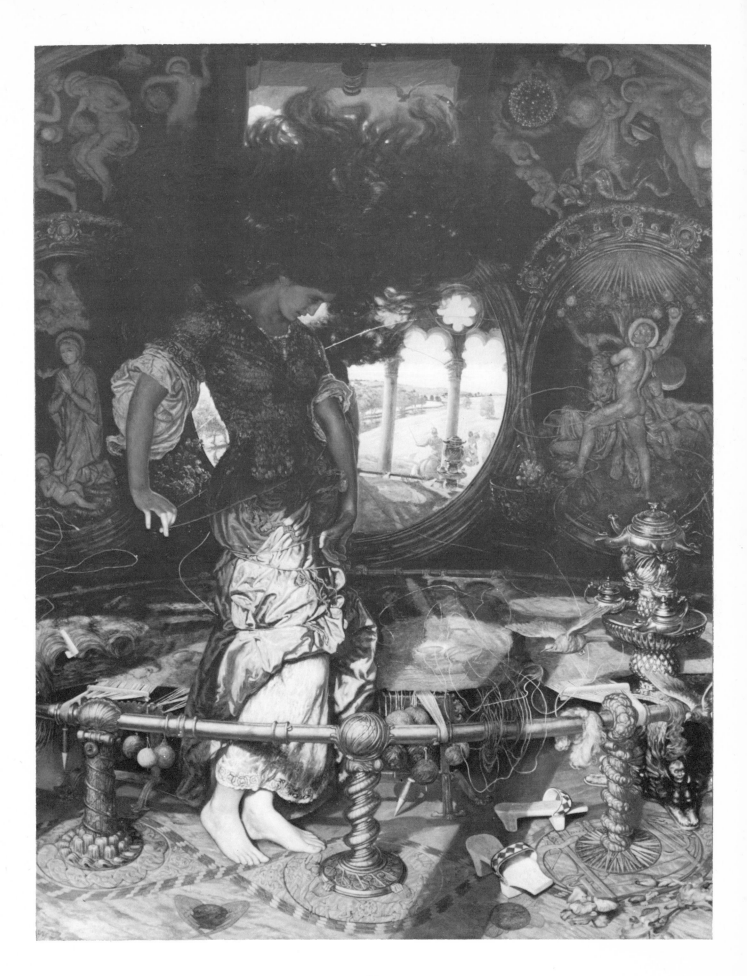

INDEX OF ARTISTS